Historic
Canada

SAINT JOHN
1877–1980

[signature]

Sept 27/2010

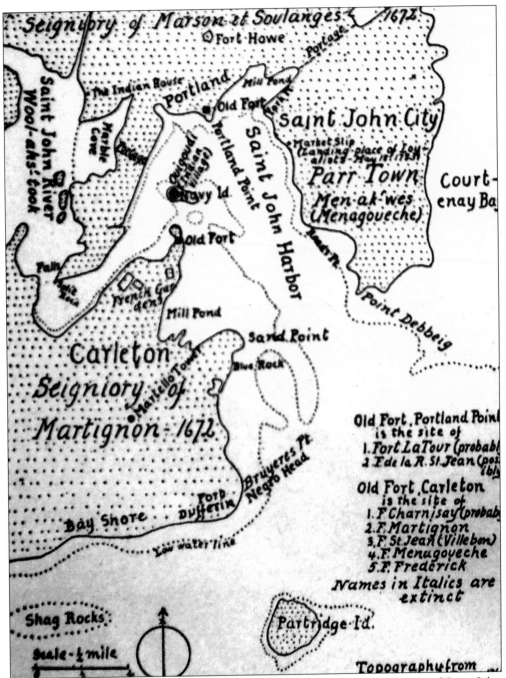

Inside the map:

Seignipry of Marson et Soulanges 1672
Fort Howe
The Indian House
Portland
Mill Pond
Portage
Old Fort
Saint John City
Saint John River Wool-ahs'-took
Marble Cove
Portage
Indian Village
Navy Id.
Portland Point
Saint John Harbor
Market Slip (Landing place of Loy-alists May 18t 1783)
Parr Town
Men-ak'wes (Menagoveche)
Court-enay Ba
Old Port
Beach N
Mill Pond
French Gar den
Sand Point
Blue Rock
Point Debbeig
Carleton
Seigniory of Martignon 1672
Marble Town
Bay Shore
Fort Dufferin
Bruyeres Pt. Negro Head
Low water line

Old Fort, Portland Point
is the site of
1. Fort LaTour (probabl
2. F de la R. St Jean (pos 1631

Old Fort, Carleton
is the site of
1. F. Charnisay (probab
2. F. Martignon
3. F. St Jean (Villebon)
4. F. Menugoveche
5. F. Frederick
Names in Italics are extinct

Shag Rocks
Scale ½ mile
Partridge Id.
Topography from ...

Prof. W. F. Ganong's 1904 attempt to update Samuel de Champlain's 1604 map of Saint John Harbour shows the various forts that protected the site, where the first settlers, the native peoples, encamped and had portages, as well as where the first permanent settler arrived in 1783. (Author's collection.)

On the cover: Please see page 10. (Courtesy Harold Wright.)

Historic
Canada

SAINT JOHN
1877–1980

David Goss

ARCADIA
PUBLISHING

Published by Arcadia Publishing
Charleston SC, Chicago IL, Portsmouth NH, San Francisco CA

Printed in the United States of America

Library of Congress Control Number: 2009930882

For all general information contact Arcadia Publishing at:
Telephone 843-853-2070
Fax 843-853-0044
E-mail sales@arcadiapublishing.com
For customer service and orders:
Toll-Free 1-888-313-2665

Visit us on the Internet at www.arcadiapublishing.com

Dedicated to my friend Harold Wright,
who I have had the pleasure to work with for 30 years now
and without whose assistance there would be far fewer photographs
to peruse in this book and far more errors to be found.

CONTENTS

Acknowledgements 6

Introduction 7

1. Streetscapes and Overviews 9

2. A Closer Look Downtown 25

3. Outside the City Core 51

4. Harbour Views 71

5. Reversing Falls 81

6. Rockwood Park 89

7. Public Events 99

8. At Play 109

9. This and That 117

ACKNOWLEDGEMENTS

This book is the result of the generosity of the people of Saint John who have provided photographic images of the city to complement the 3500 stories that I have written about the city over the past 30 years as a freelance contributor and 18-year columnist for the *Telegraph Journal*. Also, I have shared Saint John stories with other newspapers, such as the *Echo, here, Moncton Times and Transcript, Fredericton Gleaner, Montreal Gazette, Boston Globe, Ottawa Citizen*, and brought the city's past to life in local and national magazines, including the *Atlantic Advocate, Atlantic Insight, Saltscapes, The Beaver, The Leader*, and *History*. Recreation work, not writing, was my full-time career with the City of Saint John, and in carrying out my duties, I took many photographs of the activities of the Recreation and Parks Department and arranged others of events to be taken by professional photographers. I was wise enough to keep copies, which will be seen in this publication. I have, as much as possible, tried to use photographs gifted or loaned to me to tell the story of Saint John over a 100-year period roughly from the great fire of 1877 to about 35 years ago. Thus, some of the photographs may not be as clear as if they had been taken professionally, but if they told the story adequately they have been used. In using them I hope I will have honoured the people who took the time and made the effort to make their photographs or keepsakes available. I hope others will note this, and it may encourage those who have photographs tucked away to share them in whatever way they can, as this will help further tell the city's story. Unless otherwise noted, all images are from the author's collection.

INTRODUCTION

Saint John will celebrate its 225th anniversary in 2010.

Just an hour's drive west, towns in Maine claim to be 400 years old, dating their founding from the visit Samuel de Champlain and Sieur de Monts made to the area in 1604.

While Saint John could claim the same, for he visited and named the Saint John River on June 24, 1604, or could claim an even earlier time of 1525 when Portuguese explorer Estevan Gomez is thought to have visited the area, for some reason the city does not do this.

Instead the founding is based on the arrival of the United Empire Loyalists to the city on May 18, 1783, and the new city's receipt of a royal charter from King George III in 1785.

This is understandable, as before the Loyalists influx, there were only about 600 non-native people in the entire province, and Saint John became, overnight, an instant city with their arrival.

Since 1785, there have been three distinct periods that have defined how the city looks and works today.

As noted, the 1783 arrival of American settlers was the beginning following the American Revolution. Upwards of 16 000 came, and they built the city and watched it burn three times, once the year after arrival, again in 1847, and the last in 1877, it being the most catastrophic with the loss of some 1600 homes and businesses.

In those first 90 years, the city flourished, based on the timber trade and shipbuilding. In fact, the city was the fourth largest in Canada in 1867 when the nation was officially founded.

In those years, there was a constant influx of emigrants, primarily from Scotland and Ireland, bringing new ideas and new skills to the city. The later were the largest group coming to escape the famine in their homeland in the 1840s.

That is why today Saint John can be called both the Loyalist City and Canada's most Irish city.

The second period of development was the rebuilding of the city following the great fire of June 20, 1877. Shipbuilding was dying out, and the tradesmen were available to work on the structures that stand in the city to this day in the fire-devastated downtown area and give the city its Victorian character.

This is especially evident in what is known as the Trinity Royal Preservation District, basically the heart of uptown from King Street to Duke Street.

That these buildings exist is more by good luck than good planning, for as the second era of development moved along, wars and the depression shaped the city, and not for good. The economy slowed, and little in the way of change or development occurred in the 1930s and 1940s.

By the 1950s the city was anxious to get things moving, and historic structures began to disappear in the name of progress. A huge urban renewal development in the 1960s was carried out. Although much needed, as housing was inadequate for many, whole sections of Saint John lost their neighbourhood feel and their old-days look.

The city had entered its third phase and is now well into it. Today many of the industries that provided work—the nail factories, cookie and baked goods factories, sugar refineries, huge foundries, woodworking shops, lumber mills, and so on—have ceased operating. Advantages Saint John had have disappeared with confederation favoring central Canadian locations for factories and with changes in the shipping trade due first to the construction of the St. Lawrence Seaway and later with globalization of trade.

Thus, there have been many changes in the face of the city and the port operations, and heritage structures disappeared and streetscapes were altered as the city adapted to new ways of achieving economic success.

In this book, we look primarily at the middle stage, the years following the 1877 fire, until the current stage began about 1980. The photographs have been chosen to show buildings that no longer exist and others that still stand but have been altered for new uses. We see where people played in times past, the historic sites and parks they visited, and events they attended. The text has been carefully worked to provide behind-the-scenes information that adds to what is obvious from the photograph itself.

Almost all the photographs have come from private collections and were loaned or given to the author due to his interest in the history of the city profiled in this look. For the photograph data, the author is indebted to many people, but the primary source of information has been the research facilities at the Saint John Free Public Library; the New Brunswick Museum, also in Saint John; and the University of New Brunswick Library in Fredericton.

When photographs are not identified, they are usually 1970 or later photographs that have been taken by the author, who, when he took them did not realize they would someday be considered heritage material.

It is the author's hope that this book will add to the rich legacy of sharing the area's history that has been part of the Saint John tradition for most of its 225 years. Indeed, the *New Brunswick Courier* of January 2, 1841, when the city is just in its fifth decade of existence, shows that M. H. Perley delivered a lecture on the "Early History of New Brunswick" at the newly opened Mechanic's Institute. The report noted the "spacious hall was crowded with eager and attentive listeners," that his research displayed "highly interesting . . . novel facts," and that the audience of 800 gave "repeated plaudits" that "cheered the lecturer."

Additionally, the *Courier* noted, "Mr. Perley had presented the best and most authentic history . . . yet published."

That is a tough act to follow even though there is much more to review 150 years later than M. H. Perley had to work with.

One

STREETSCAPES AND OVERVIEWS

King Street is seen prior to the great fire of June 20, 1877, which destroyed the south peninsula, from King Street to the waters of Courtenay Bay. About 1600 homes were lost, as well as the principal businesses, leading churches, hotels, and theatres. The rebuilt city has buildings that are considered among the finest Victorian structures in Canada, and some of that will be seen in the overview scenes that follow. (Courtesy Terry Keleher.)

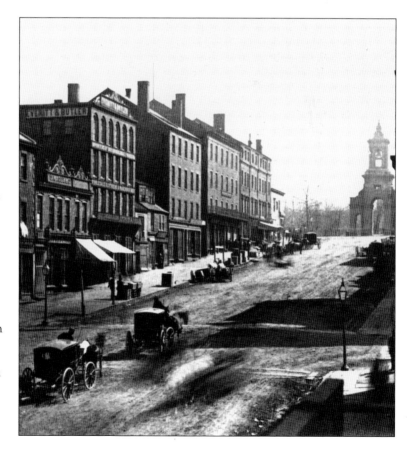

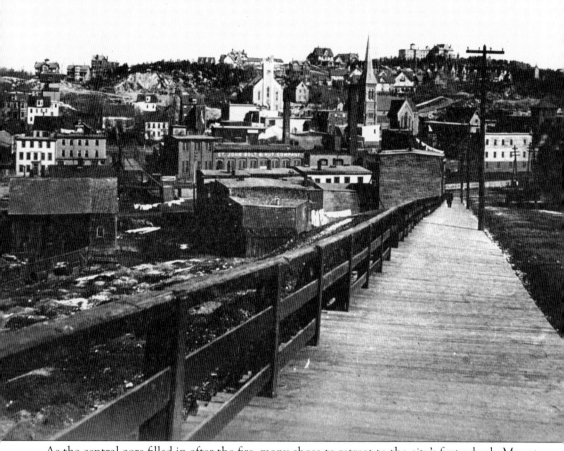

As the central core filled in after the fire, many chose to retreat to the city's first suburb, Mount Pleasant. Reed's Castle stood at its highest point, to the right of the St. Paul's Church steeple. The railway came to the valley in 1853, and men working for the Intercolonial Railway soon filled the hillside between the tracks and the castle with new homes, most of which still stand. (Courtesy Harold Wright.)

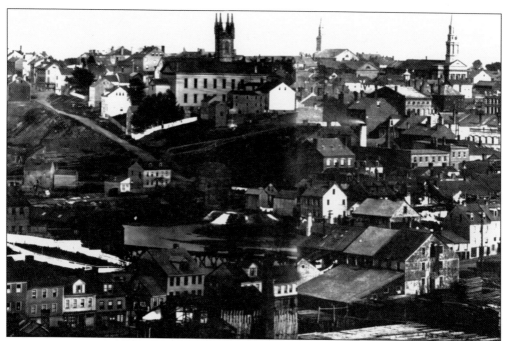

Taken from Fort Howe, these two views show central Saint John before and after the great fire of 1877. Before the conflagration, in the top photograph, Trinity Church, with its faux front built in 1856 to include Ionic columns and a tall rooftop spire with a clock face, clearly shows. It is the most prominent central city building, which is exactly what its congregation wished to convey with the renovation of its 1791 building. To its left, with four spires highly decorated with grotesque faces, is Saint John's (Stone) Church. It was built in 1824, and as one of the city's first non-wood buildings got the nickname "Stone," by which it is still known to this day. It survived the fire. Unfortunately, it did not survive the photographer's cut and does not appear in the lower photograph. (Courtesy Harold Wright.)

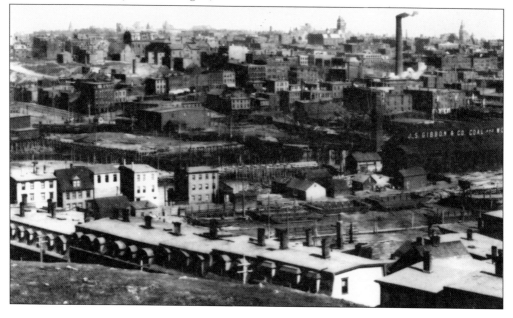

Before the era of industrial parks, huge manufacturing concerns like McAvity's moved no farther from the central city core than necessary to find land for their sprawling works. McAvity's produced fire hydrants for markets all across Canada from this Rothesay Avenue plant. Its proximity to the city meant workers could walk to the job, a big plus when this photograph was taken in the early 1940s, when few had cars. (Courtesy Harold Wright.)

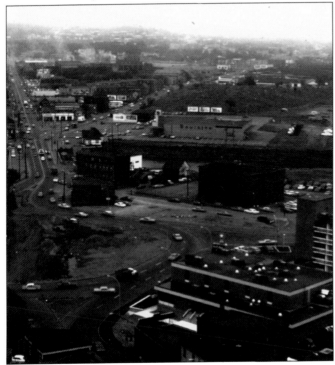

The Haymarket Square, which was truly a farmers' market for hay but became a public square in the 1880s, all but disappeared with the 1960s urban renewal of the East End. Note the piles of gravel as the square is being shrunk to allow a traffic rotary, which proved very unpopular. Also note the Holiday Inn on the bottom right, which opened in 1965. (Courtesy Harold Wright and City of Saint John.)

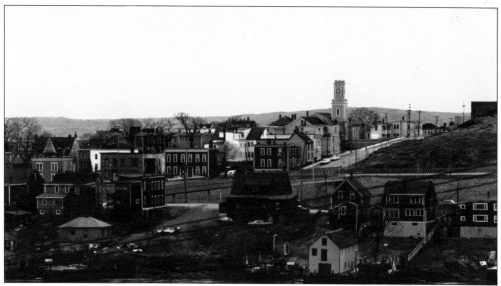

The west side of Saint John lost over 60 homes when the throughway cut through the north side of the community in the 1960s. The distinctive octagonal tower of 1821 St. George's escaped razing, but the church lost a third of its parishioners to throughway construction. On the river edge, the Stackhouse boathouse (right of centre) is the last of many that stood on Water Street and built dories for the salmon fishing industry.

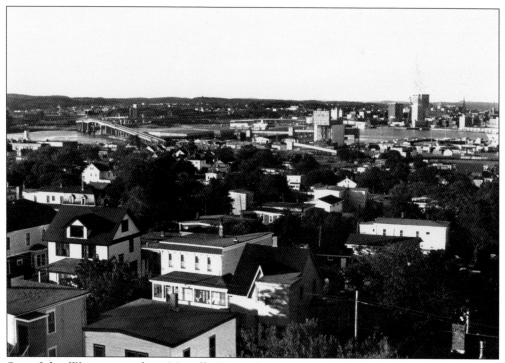

Saint John West is seen from Martello Tower, looking toward the harbour and the Harbour Bridge, whose effect in displacing city residents on both sides of the river seems benign from the 210-foot hilltop on which the tower has stood since about 1812.

From another hilltop, Fort Howe, this photograph shows the Mount Pleasant area noted on page 10, specifically First and Second streets, given over to apartment living. Behind the 1930s apartments are private homes, many of them grand structures built by the city's business elite in the 1880s. These sumptuous residences not only provided great views of the city but escape from the industrial clamour of the downtown.

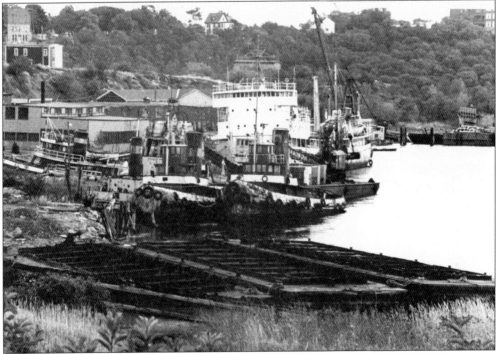

Indiantown at the end of Main Street in the city's North End served as the riverboat connection with central New Brunswick via the Saint John River from 1838 until 1945. A thriving business community built and repaired the boats, refurbished tugs, made scows seaworthy, and so on. Hardware stores, grocers, and hotels all carried on lively trade. Lumber mills and lime-burning operations also operated in the area, and it was the terminus for the city streetcar operations.

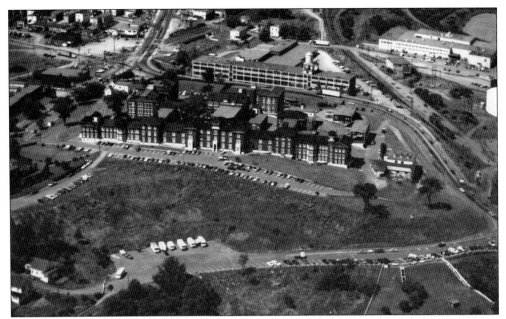

Main Street, on the west side of the city, depended on industries like the various mills at Reversing Falls, the Canadian Pacific Railway on Paddy's Flats, Moosehead Breweries on Main Street, as well as lumber mills and liming operations about a kilometer away in Randolph for its mercantile success. In 1953 the area became the City of Lancaster; in 1967 the area was forced to amalgamate with Saint John. (Courtesy Harold Wright.)

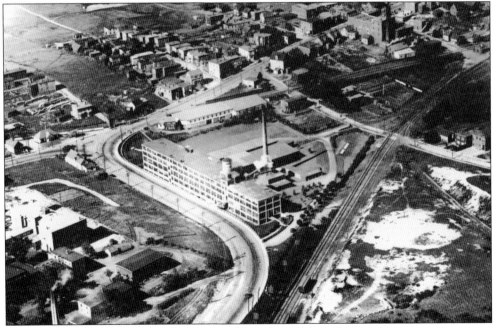

This aerial view again shows Main Street, with another of the industries that were so important to its success, the Simms Brush and Broom Factory. Hardly a resident of the area did not have at least a short stint working for the company, which was established on the site in 1913 and is still there today. (Courtesy Harold Wright.)

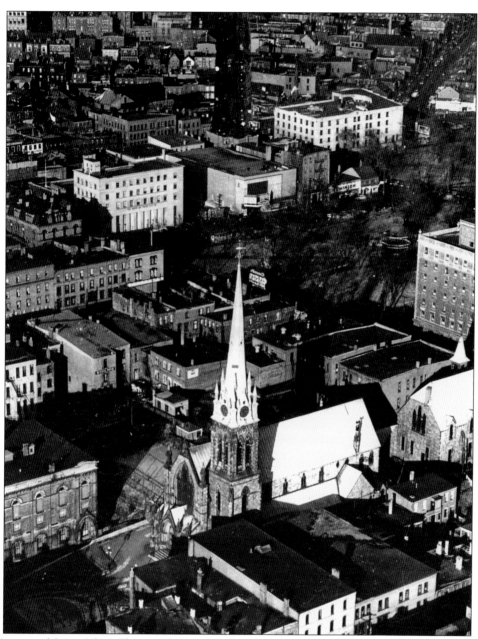

"A view of Saint John's Flying Fish" was the headline atop this photograph when it appeared in the *Telegraph Journal* of January 10, 1949. Taken from an airplane by cameraman Joe Stone of Climo Studio, the 60-year-old photograph shows many of Trinity's neighbours that no longer exist or whose premises have new uses. For example, on the north boundary of King's Square, the corner building, the 1939 Bank of Nova Scotia, is now part of the University of New Brunswick in Saint John; mid-block, the 1948 Paramount Theatre now stands empty; and at the end of the block the Dominion Stores is an office building. Cars seen atop the Golden Ball (beyond the Dominion Store) building may come as a surprise to those who do not know it began life as a parking garage. The "flying fish" is 210 feet from ground level and is almost 6 feet long, although it looks much tinier in this photograph. (Courtesy Trinity Church.)

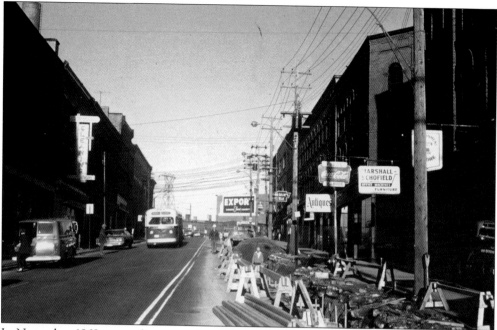

In November 1969, power lines were being buried under the pavement of Dock Street, which has since been renamed to honour the Irish immigrants to St. Patrick Street. The only structure still standing in this photograph is the Red Rose Tea building in the background, with an Export cigarette advertisement, although at that time they were still packing the tea that made Estabrook's famous. (Courtesy Saint John Energy.)

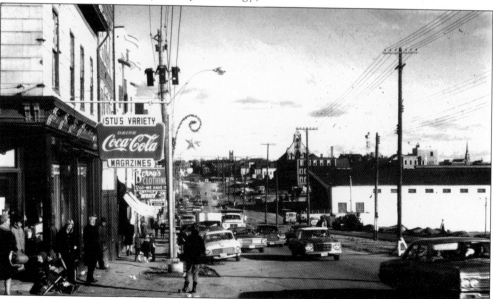

Stu's Variety, at the corner of Main and Lansdowne streets, is shown in December 1969. This was the former Driscoll's Drug Store (page 51) and is now a McDonald's location. In the background is the newly built (1960) Lord Beaverbrook rink, which still stands. Beyond that the 1881 Portland (Methodist) United Church can be seen. It was closed in July 1970 and torn down soon after that. (Courtesy Saint John Energy.)

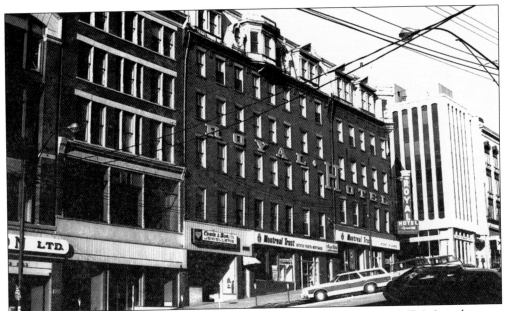

The department store Manchester, Robertson, Allison, Ltd., also known as MRA (see also page 35 and page 125), jeweler Cowie and Son, Montreal Trust, and Royal Hotel were all closed on December 31, 1976, when this photograph was taken prior to the block being razed to make way for Brunswick Square (see page 28). Of the four, only Cowie and Son still operates on King Street today. (Courtesy Saint John Energy.)

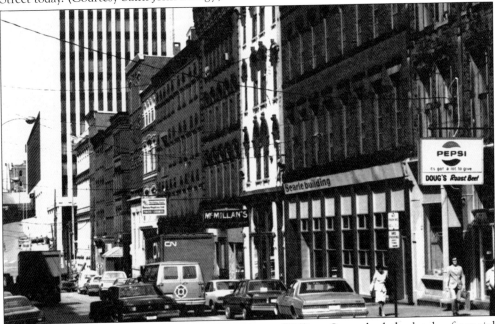

Nicknamed the "Wall Street of Saint John," Prince William Street had the banks, financial institutions, investment houses, and insurance agencies to justify that title in the late 19th century. While that is no longer the case today, the buildings that housed these businesses survive with different uses, and today the street has been recognized by Heritage Canada as having the best intact collection of Victorian structures in Canada.

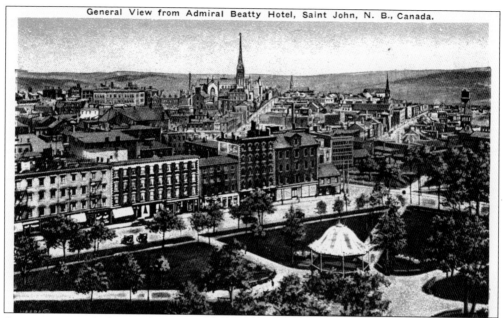

General View from Admiral Beatty Hotel, Saint John, N. B., Canada.

An artist positioned atop the city's leading uptown hotel, the Admiral Beatty (see page 34), captured King's Square and surrounding buildings of North King Square (see also page 16) about 1915. The buildings pictured would have been great fire survivors, and most were worn out and torn down by the 1950s. In the background the 230-foot spire of the Cathedral of the Immaculate Conception is seen atop Vinegar Hill.

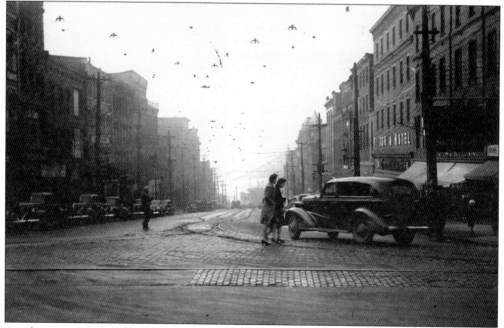

At what is popularly called the "Head of King," two ladies make their way across King Street at Charlotte Street in this *c.* 1940s photograph. It is eight stories from the bottom or "Foot of King" to the top, and the ladies are likely glad to be going downhill. Local lore has it that a benefit of the Saint John hills is that the ladies of the city have the shapeliest legs in Canada. (Courtesy Rod Daley.)

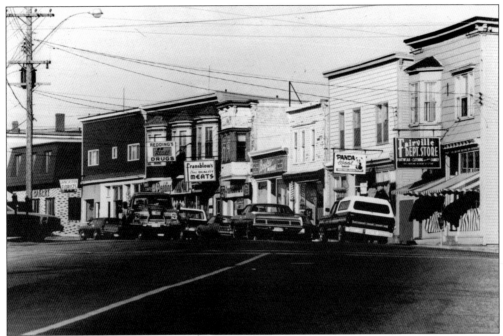

Saint John had thriving neighbour business zones in the east around Haymarket Square, in the west around Union and King streets, and in the north of the city on Main Street and around Indiantown. Main Street, west, known as Fairville still has a vibrant local business presence. Lancaster Florists and Steen's Barber Shop from this 1970 photograph are still operating, while the other buildings have new owners and businesses.

Duke Street, west, is one of the city's most historic streets. At its foot (centre of the photograph) is the Carleton Public Hall (1863). On the next corner, behind the house spire, is 1791 Sewell House. In the next block, the first mayor's house stood. He held a pew in 1821 St. George's, the city's oldest church. The photograph was taken from its 66-foot octagonal tower. (See page 13.)

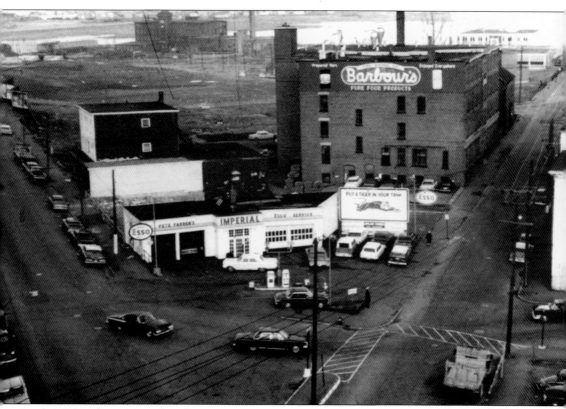

In the 1950s there were often four competing service stations on a busy corner, and Imperial and Irving would always be two of them. This is the Prince Edward Street and Union Street junction; Imperial is obvious, but Irving is at the bottom and out of the picture. Behind Pete Farren's Esso is the G. E. Barbour spice, coffee and pure food plant, which left the area for Sussex in 1966. (Courtesy Harold Wright.)

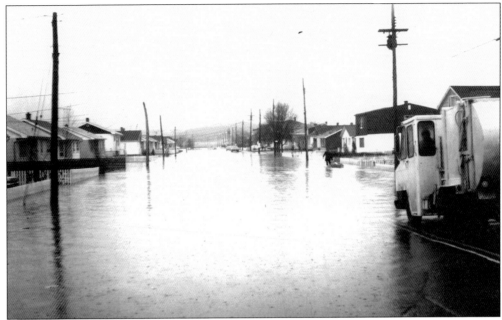

Floods on the great marsh, especially in Glen Falls as shown here in February 1970, became such a plague that they brought a new political era to the city when a resident of the flood area, Elsie Wayne, ran for the mayoralty to help alleviate the problem. She won in 1983, served for 10 years, and accomplished much, but nature still occasionally wins the day. (Courtesy Saint John Energy.)

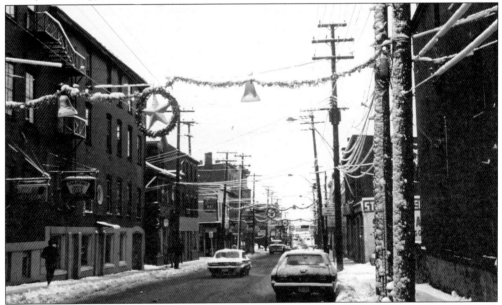

This is Union Street at Germain, decorated by Saint John Energy for Christmas 1969. The non-profit company founded to bring cheap power to Saint John in 1922 undertook the lighting of the first Christmas tree in 1928 in King's Square, and in 1951 the first sets of lights adorned King Street, Dock Street, and Main Street, firstly to greet Princess Elizabeth and then to cheer shoppers. (Courtesy Saint John Energy.)

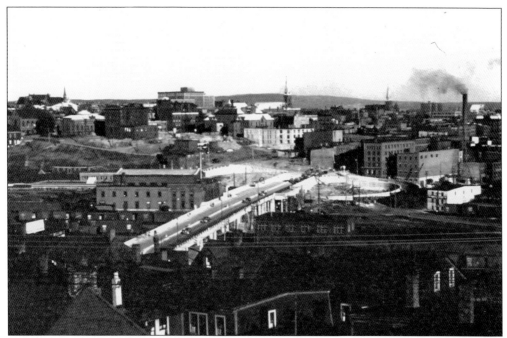

As Canada's official winter port, great quantities of goods were moved by rail from wharfside to inland locations. This resulted in many delays at level railway crossings such as Simms Corner, Kanes Corner, and Haymarket Square, but the worst was on Mill Street, which led to the city core and is where a viaduct was built to alleviate the situation in 1951. (Courtesy Harold Wright.)

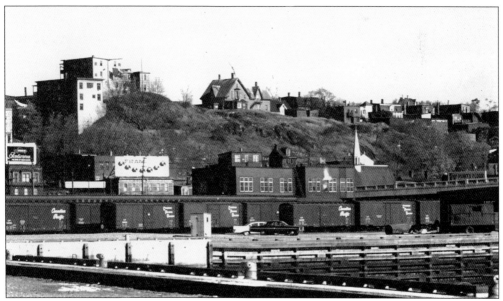

Pictured is the Union Station rail yard over which the viaduct shown above was built. In the background is the spire of Mission Church, since torn down. In back of the church tenements stand high on the streets surrounding Fort Howe. They were also removed in the 1970s. In the 1990s fine homes were built to take advantage of the great views of the harbour the area provides. (Courtesy Saint John Energy.)

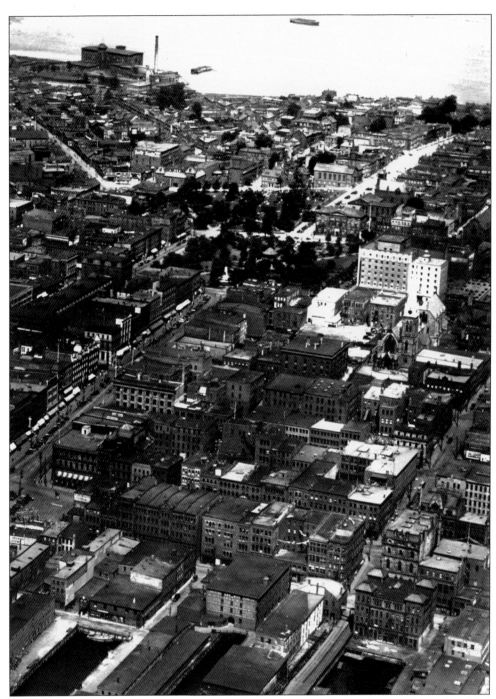

This aerial view of Saint John centre looking west to east was taken in 1930 by a pilot, likely Wendell Rogers, flying out of new Millidgeville airport for Atlantic Airways. Harold Wright identified the photograph and pilot from information he has gleaned for a book he is preparing on the history of Saint John's second airport, with the first, surprisingly, at Quinton's Farm, Manawagonish Road, Saint John West. The Millidgeville airport closed in 1951, and the land is now built upon and is now a vibrant subdivision. (Courtesy Harold Wright.)

Two

A Closer
Look Downtown

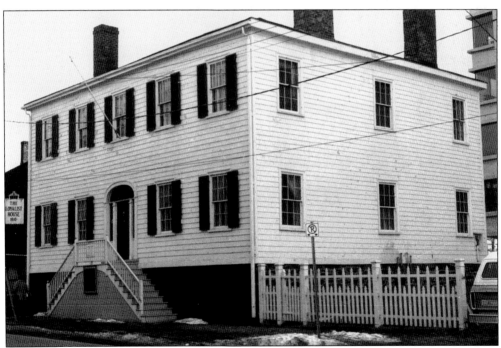

Loyalist House is a Georgian-style "house on the hill" and was built by Loyalist David Daniel Merritt about 1810 and reflects his success as a merchant at Market Square. This chapter provides closer views of homes and businesses in the city core and provides an understanding of how the city developed, how some businesses and industries flourished while others passed from the scene, how some development plans came to fruition while others did not, and how streets, parks, and public houses came to be and how they have changed.

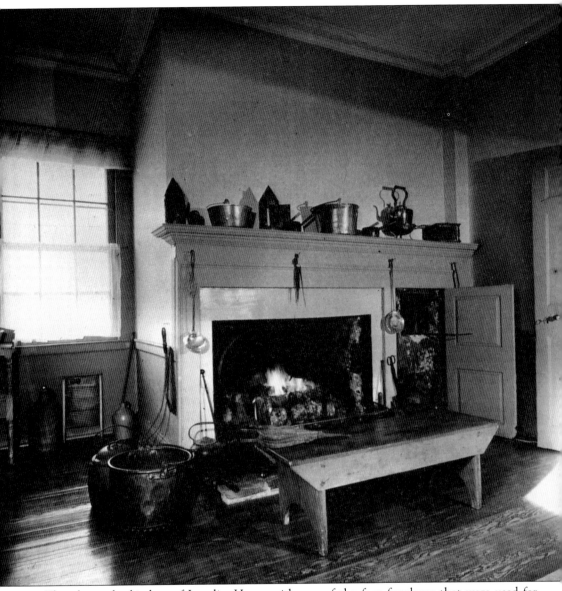

This shows the kitchen of Loyalist House with one of the four fireplaces that were used for heating the grand home and, in this case, for cooking the meals. Servants working in this room responded to the call of bells when one of the Merritts wanted attention. Note the utilitarian bench and washstand, which sharply contrast with the fine furniture that exists in other rooms of the house. (Courtesy New Brunswick Historical Society.)

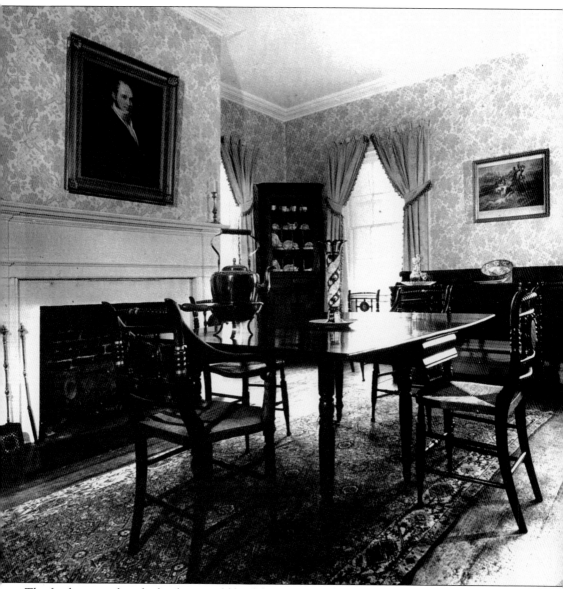

The food prepared in the kitchen would be delivered to the formal dining room, laid out on fine imported Duncan Fife furniture, and eaten from Wedgewood china, using fine silverware, also imported from England. This room is still used for formal occasions, such as Christmas socials, Canada Day celebrations, and the mayor's tea once a week during the summer season. (Courtesy New Brunswick Historical Society.)

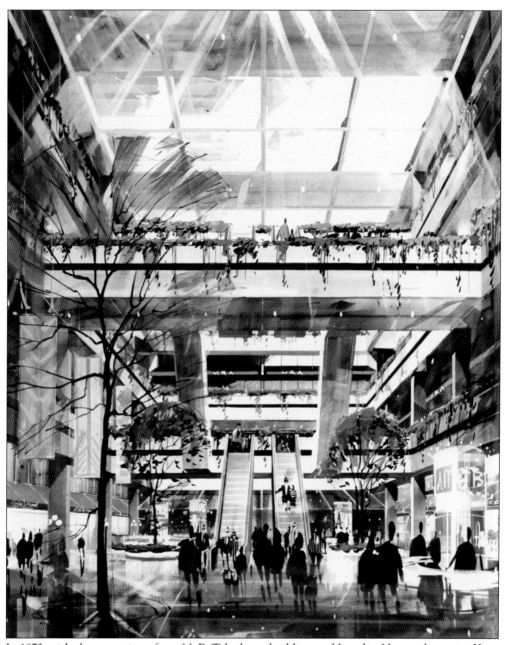

In 1973, with the exception of one N. B. Telephone building and Loyalist House, the entire King Street, Germain Street, Union Street, and Chipman Hill block was torn down and redeveloped as Brunswick Square. This is an artist's depiction of how the central atrium was to look when complete. Note that MRA department store (see pages 35 and 125) was to continue to exist; however, that did not happen. (Courtesy New Brunswick Historical Society.)

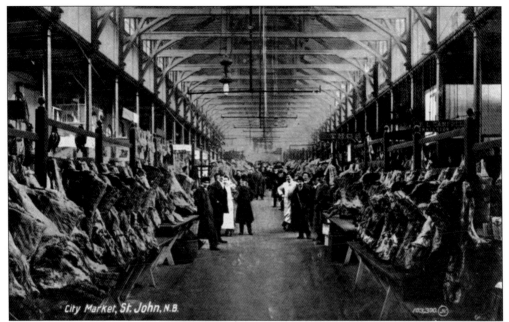

City Market, St. John, N.B.

In 1876, when the city market opened, it was one of four markets in the city, there being a hay market, a fish market, and one other farmers' market. An all-powerful market clerk kept the merchants on their toes and could fine them on the spot if they sold shoddy merchandise. In 1945 the city was prepared to sell the then-rundown market so a national department store, the Met, could tear it down and build a five and dime store type of operation. Fortunately, that did not happen, and the market was later refurbished. A survivor of the great fire of 1877, today it is a very treasured heritage structure, as well as a great place to shop in the centre of the city. In the background is the Brunswick Square development's N. B. Telephone Tower noted on the previous page.

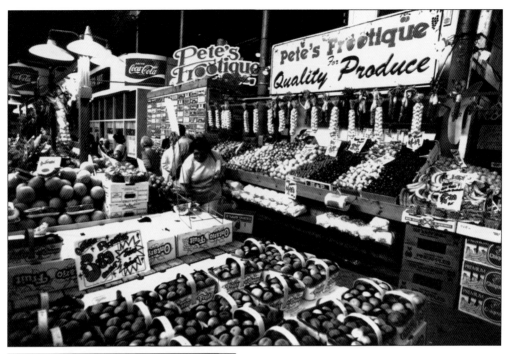

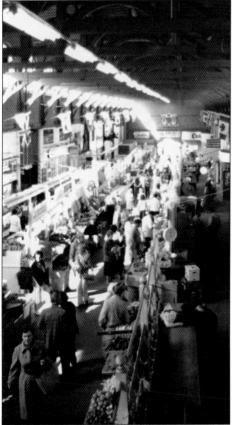

These two interior shots of the market illustrate the mix of tenants that operate in the market. Although stall rentals are week by week or month by month, some tenants, like Slocum and Ferris, Dean's Meats, and Jeremiah's Deli, have been there for decades. Pete's Frootique is a later arrival but has now been in the market for a quarter century. Its owner, Pete Luckett, has built a national reputation as an expert in the produce field, and it all began with the stall pictured in the upper photograph in the 1876 city market.

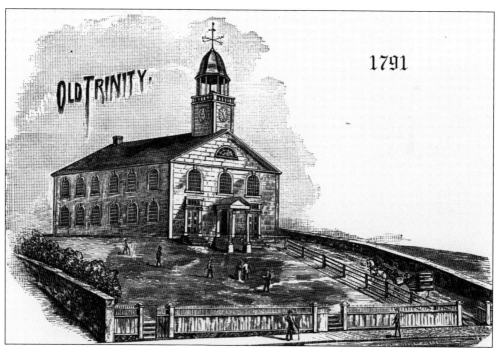

Another remarkable downtown structure has been Trinity Church at 115 Charlotte Street. There has been a church on the site since 1791 serving the city's Anglicans. The first church was wooden and very Congregational in style when built and is shown in the top photograph. In 1865 the exterior of the original building was modified to closer reflect its association with the Church of England, noted for its grand structures in the mother country. This church burnt in 1877 and was replaced in 1880 by a grand English Gothic–style structure built of local limestone, which still stands and is shown from the air on page 16. (Courtesy Trinity Church.)

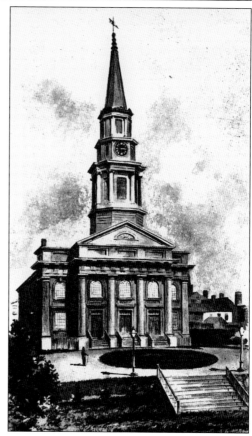

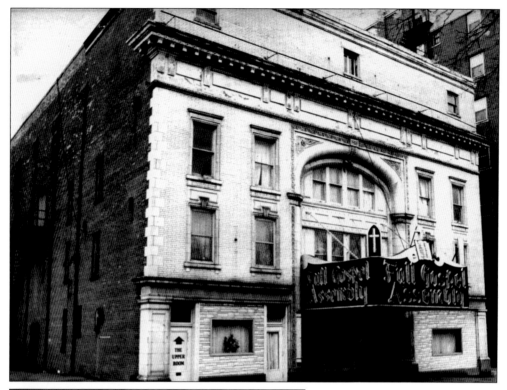

Looking quite ragged in its incarnation as a Pentecostal church from 1957 to 1982, the 1913 Imperial Theatre was restored in the late 1980s to its original grandeur and use. It is now considered the leading theatre of the Maritimes, and one of the best in Canada, and in 1982 Jack MacDougall (left) offered the church $1 and a promise to raise $1 million to buy the structure within a year. At the time, many thought he was crazy, but the citizens got behind the idea and enjoy top-line productions there to this day.

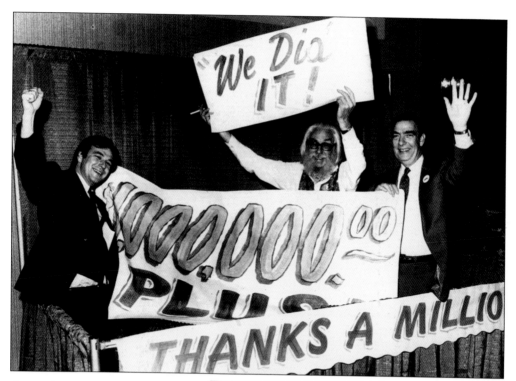

As can be seen from the top photograph, Jack MacDougall (left), Job Hawkes (center), and Tom Condon are in a celebratory mood as they have the $1 million to pass over to the church for the Imperial Theatre. One of the films shown in the first 10 years of life of the Imperial was the made-in-New Brunswick feature *Blue Water*. It was shot in the fall of 1922 around Saint John and Beaver Harbour but had to be finished in Florida. It did not prove to be as successful as some of the other Ernest Shipman productions that had been made from coast to coast in Canada. It starred Norma Shearer, and while she later won an Oscar, the New Brunswick–made film was a bit of her career she was reluctant to talk about. (Right, courtesy National Film Archives 2046.)

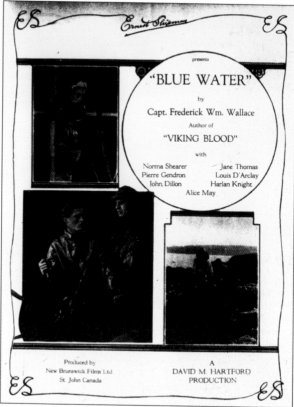

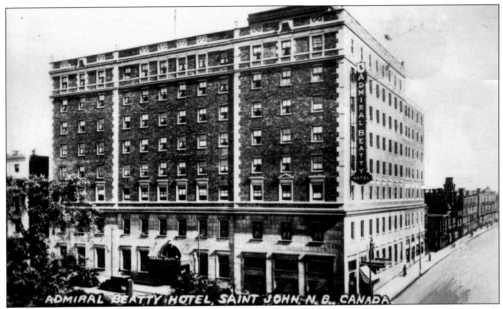

ADMIRAL BEATTY HOTEL, SAINT JOHN, N.B. CANADA

Those attending a presentation at the Imperial or a service at the Full Gospel Assembly church could spend the night in the city's leading hotel right next door, at least after the year 1925 when it was built until it closed in November 1982. Or they might drop over to the Riviera Restaurant on Charlotte Street for an after-dinner meal or drink or to Nicholas Brothers for lighter fare, as both were but a minute from the theatre. The later two businesses were torn down to make way for a regional Royal Bank of Canada building in the 1980s.

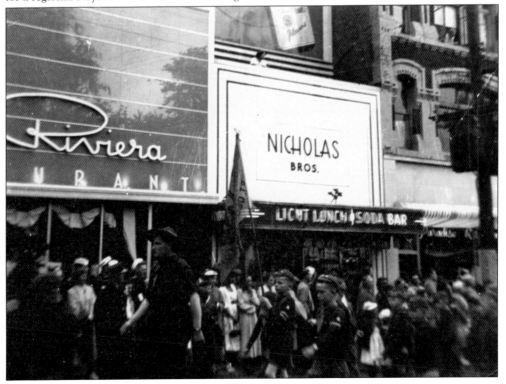

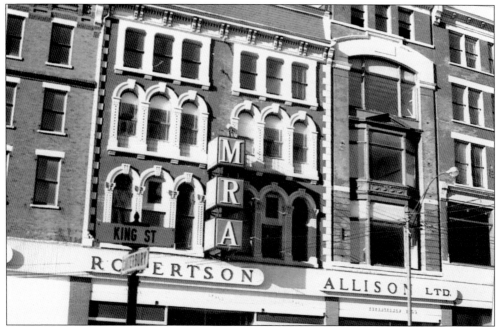

MRA boasted it was the Maritimes' leading department store in its advertisings. Opened in 1866, it thrived and grew to occupy several buildings on King Street and Germain Street. The firm, owned locally except for a very few years, did business nationally and internationally until it closed in December 1973. Originators of the first Santa Claus parade in the Maritimes in 1951, the stores are remembered to this day as a great place to shop. The opening of Sears in 1955 (see page 69) was the first outside challenge the store faced. As in most jurisdictions, local stores like MRA, good as they might have been, could not sustain their customer base against the buying power of national retailers. (Courtesy Saint John Energy.)

While the great fire of 1877 devastated Saint John, taking out dozens of central city business concerns, the city was also visited by fires on many more occasions in the years that followed. Two examples given here are of a January 22, 1943, fire that did $350,000 damage in buildings surrounding the then-new Bank of Nova Scotia on Charlotte Street and King Square north. Among buildings burned were the Calp's Department Store (shown) and the La Tour and Edward Hotels. Earlier, on January 13, 1919, a $35,000 fire destroyed the Gem Theatre on Waterloo Street and damaged a grocery, a barn, and a stable. These are but two of many examples of the scourge of fire that could be shown.

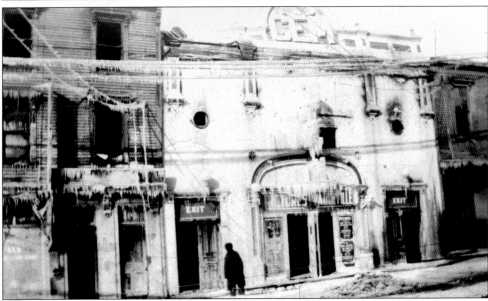

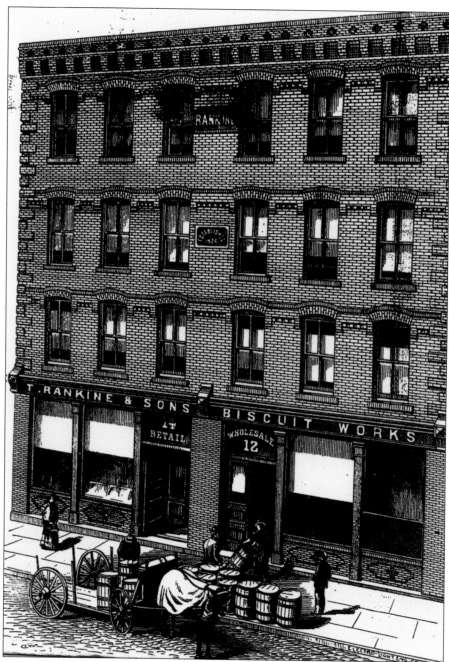

Even after the age of photography, it was still cost effective to have a steel engraving done for illustrative purposes in the local papers and for use on letterheads, business cards, and commercial mail cards. In the later category, postal efficiency was so great that cards would routinely be delivered the next business day in Montreal, Toronto, or even New York. This cut is of the Rankine Biscuit Works founded in 1826. The company was the preferred supplier of baked products for the wooden ships that called in Saint John, with hardtack ship biscuits being their best seller. In the mid-19th century, when Rankine's business peaked, Saint John was the fourth-largest ship-owning port in the world.

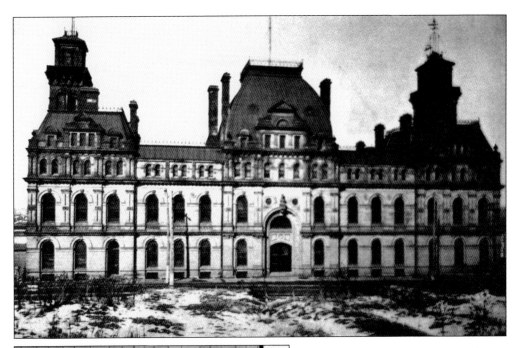

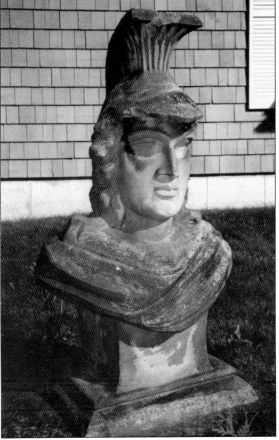

Architects McKean and Fairweather designed the customs house that dominated the streetscape of Prince William Street at Duke Street from just after the great fire until 1960. Its size reflected the huge movement of ship traffic in the harbour. By the 1950s it was considered out of date and was razed, with a similar-size structure, although not similar in architectural detail, erected on the site. Most of the rubble from the original building was used by the contractor, George Chittick, as landfill in front of his McLaren's Beach home. However, a few of the more decorative elements were saved and survive in private hands, such as Caesar, show here.

The 1895 Canterbury Street Provincial Building was originally an extension of the Aberdeen Hotel, opened in 1879 by G. R. Pugsley. The Aberdeen boasted such amenities as tube telephones connecting the 100 sleeping rooms and front desk, a flush toilet on each floor, and a rooftop dining area with gardens where a Parisian chef prepared meals. Also for the convenience of guests was the first elevator in any hotel in the Maritimes.

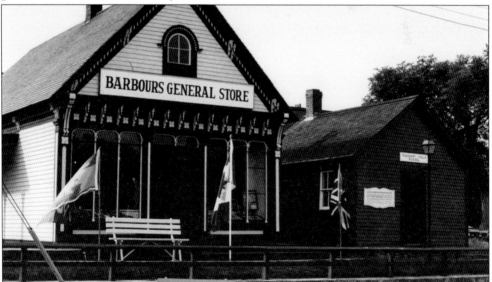

In 1967 Ralph Brennan of the G. E. Barbour Company was alarmed that his granddaughter did not know what coal was, nor many other day-to-day items he had known as a boy. He decided to have a country store installed in the heart of the city of Saint John. Thus, what is now the Barbour's General Store was towed down the Saint John River and carefully stocked with items from yesteryear.

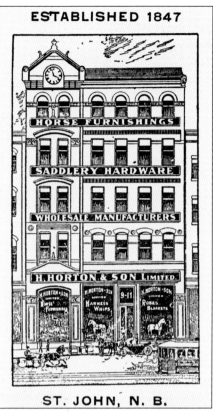

H. Horton and Sons, later Horton and Walsh, began business on Union Street in 1847 when Henry Horton completed his studies in Halifax in the "art and history of harness making." He operated in three locations before settling at 9–11 Market Square in 1898. The firm carried out business locally, nationally, and internationally until 1968, at which time the location was bought for the new city hall, and it closed when the firm was unable to find suitable premises for the business to operate. (Courtesy Bob Horton.)

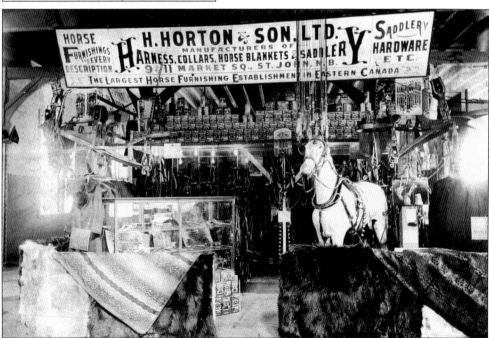

The horse pictured, made of plaster of paris, stood in the Market Square store, and Bob Horton, whose dad was the last owner of the business, recalls "many a child was lifted onto his back."

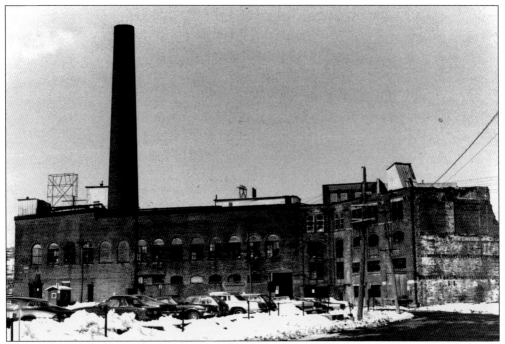

The first power plant in Saint John was producing electricity from a plant on Paradise Row in 1884, which was just two years after Edison perfected the incandescent light bulb! The Eastern Electric Company established the plant (pictured as it was being demolished in 1976) in 1889 on Union Street. It had various owners, its last being the New Brunswick Electric Power Commission. It also had many modifications over the 87 years of its life and at the end was producing 18 000 kilowatt hours, but that was a very small amount in the nuclear age.

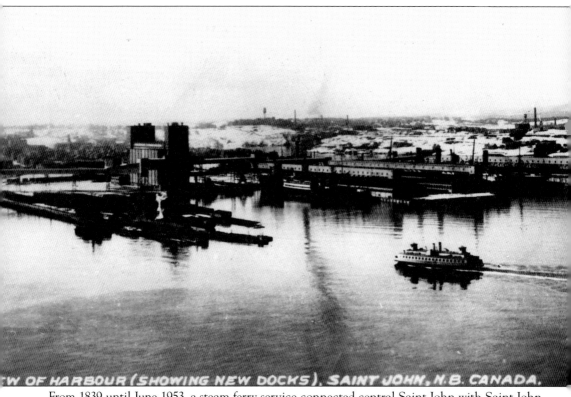

From 1839 until June 1953, a steam ferry service connected central Saint John with Saint John West. From 1878 onward, those leaving from the Princess Street dock passed through a fairly substantial building clearly labeled Carlton Ferry, which was the name most people used for west Saint John at the time. No fancy building existed on the Carleton side, as the ferry had to dock well out into the harbour and passengers had to walk a long floating dock to dry land. The ferries that operated included the *Victoria* (1838), the *Lady Colebrook* (1841), the *Prince of Wales* (1860), and *Ouanqondy* (1870) along with the *Western Extension* at the same time, the *Ludlow* (1905), the *Governor Carleton* (1911), and the last one, the *Loyalist* (1933–1953). (Courtesy Audrey Taber.)

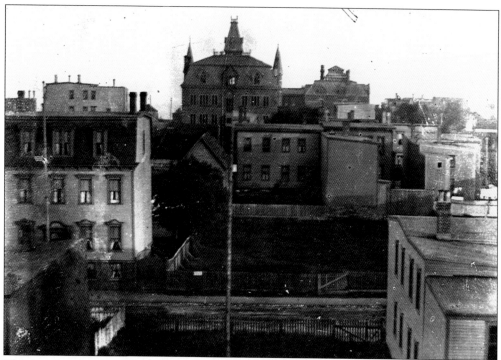

This is a mystery page. These two photographs were among some 50 glass photographic plates in the attic of the Loyalist House, (see pages 25–27). All the others are clearly Saint John scenes, and several of them can be dated to around 1880. (See two others on page 73 as an example.) Despite the fact they have been displayed for three summers in the house and many local history buffs have seen them, no one can say for sure just what is being depicted. Some think they may have been prefire photographs, but the architecture suggests post fire. Perhaps with a wider audience, there will be a positive identification made. (Courtesy New Brunswick Historical Society.)

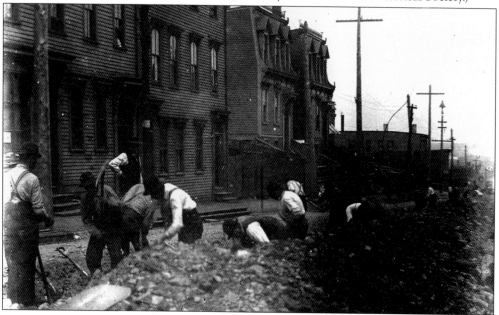

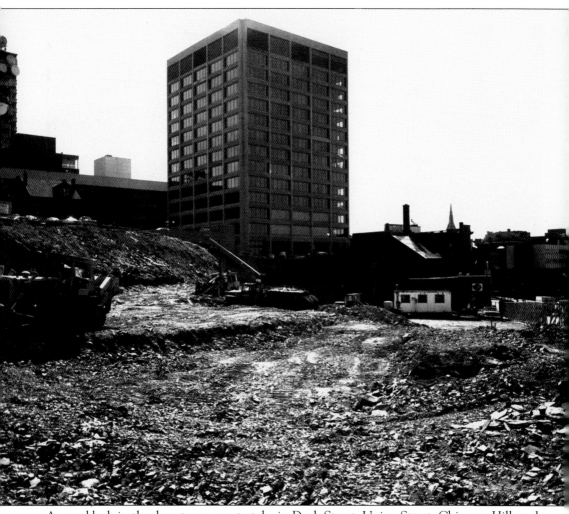

A superblock in the downtown core to take in Dock Street, Union Street, Chipman Hill, and North Market Square was the impetus for tearing down a dozen of the heritage structures in the area, but only the city hall pictured here was actually constructed in the late 1960s, opening in 1971. Later the Aquatic Centre was built, and the removal of rock for its foundation appears in the foreground of the 14-storey city hall building, the city's second high-rise. (Courtesy City of Saint John.)

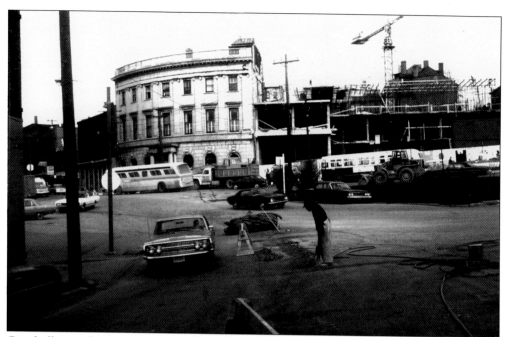

City hall is under construction in November 1969. Two buildings that were not demolished show in this photograph too. To the left of the city hall is the Canada Permanent Trust Building (with the round facade), and behind the city hall is the prefire Pratt building. Its features include interior trompe l'oeil paintings by unknown European artists and exterior carved doors by local woodcarver John Rogerson. (Courtesy Saint John Energy.)

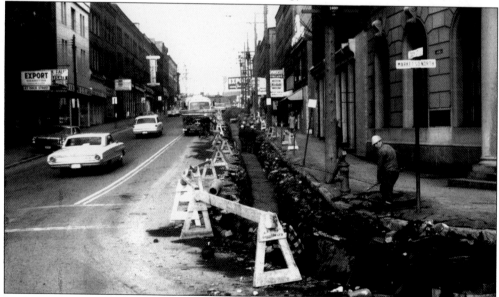

Underground wiring is being placed on Dock Street in November 1969 by what was then called the Power Commission of the City of Saint John. Formed in 1922 to provide "power at cost," this well-managed company has served the citizens of Saint John magnificently and manages to undertake projects like the burial of wiring and still provide power at 10 percent less than most New Brunswickers pay. (Courtesy Saint John Energy.)

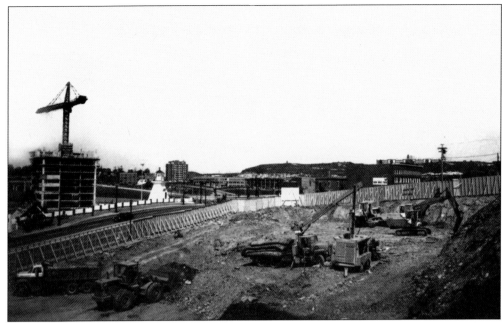

The Aquatic Centre development, looking north, was the other major construction that filled in the superblock zone. In the background is Fort Howe, where the first rock was quarried in the city by Simonds, Hazen and White in 1763. Development in Saint John was and is difficult due to this rock, and where there is not rock, there is often swamp. (Courtesy Harold Wright.)

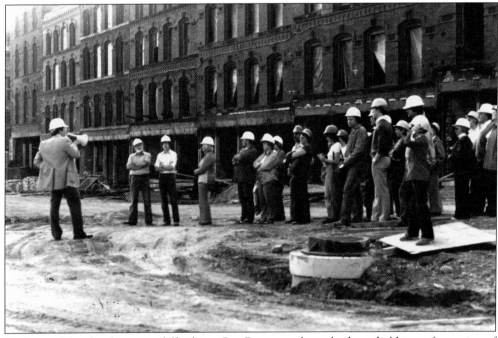

Undeterred by development difficulties, Pat Rocca undertook the rehabbing of a series of warehouse properties at Market Square in the late 1970s. Paul Duncan is shown here explaining to a group of citizens how the 1877 warehouses will be rehabbed to serve as restaurants, bars, clothing stores, and offices.

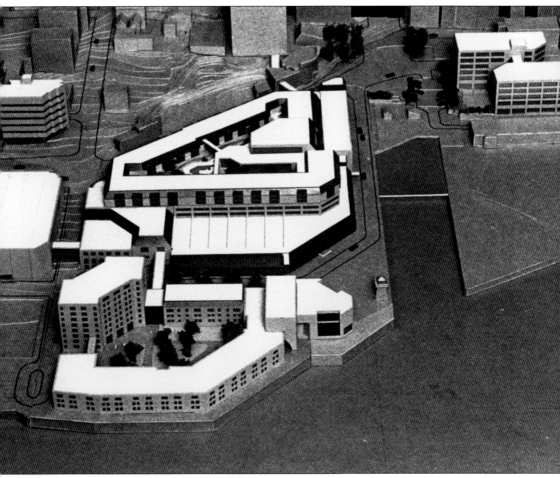

This photograph is an architectural model of the redevelopment of Market Slip that the Rocca Company undertook in the late 1970s. The project not only rehabilitated the crumbling 1879 warehouses, it resulted in many new shops and businesses locating in the Prince William Street area. At the Market Square project, the city got a new library, a convention centre, and eventually, a new hotel, the Hilton. Later the New Brunswick Museum moved into the complex. (Courtesy City of Saint John.)

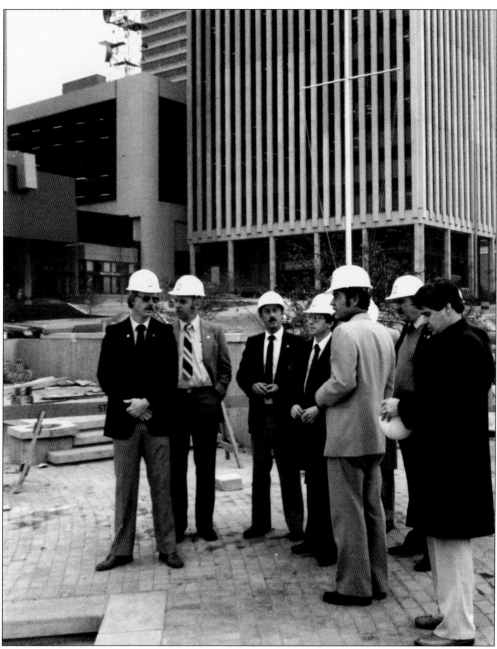

Curious about downtown revitalization, visitors came from across Canada to see what was happening in Saint John. Here the work in progress at Market Square is being examined by, from left to right, Pat Palmer; Doug McCaig; Ken Campbell of Saint John; Denny Neider, Canadian Parks and Recreation Executive Director; Pat Rocca, developer; Jack Boutillier, President of the Canadian Parks and Recreation Association; and Ken Gould, City of Saint John Councilor. (Courtesy City of Saint John.)

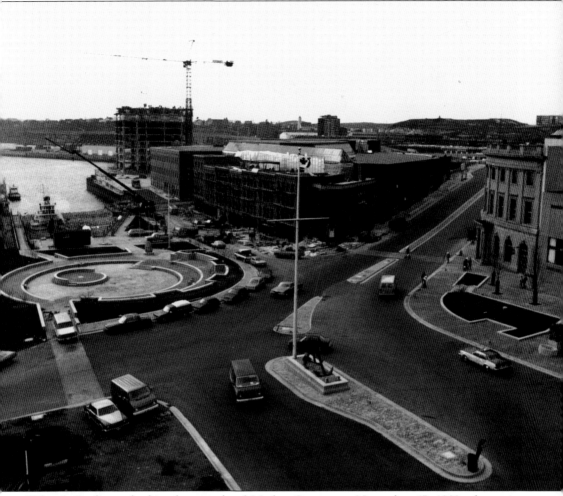

Wilson's Studio took this photograph of Market Square on November 17, 1982, about six months before the official opening on May 18, 1983. That date marked the city of Saint John's 200th birthday, and the Market Square development was a fitting way to celebrate. The Hilton Hotel in the background is up to eight stories at the time the photograph was taken. The tug *Ocean Hawk 11* is being lowered into its reflecting pool at the very point at which the first settlers are said to have landed 200 years earlier. (Courtesy Wilson's Studio and the City of Saint John.)

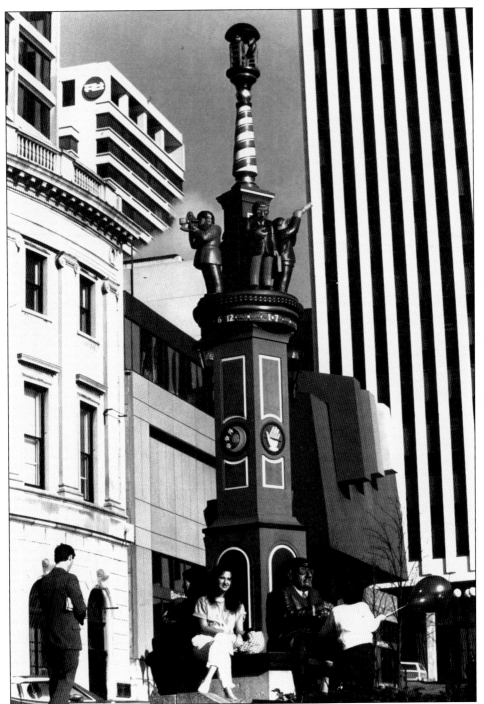

The Market Square development included funding for several pieces of public art, one of the first projects to do so. None has drawn more attention over the years than the "Timepiece," at the east entrance to the atrium. The work was conceived and executed by John Hooper and Jack Massey. Thousands have since had their photographs taken with the various figures who are all passing time in one way or another. (Courtesy City of Saint John, Tourism Department.)

Three

OUTSIDE THE CITY CORE

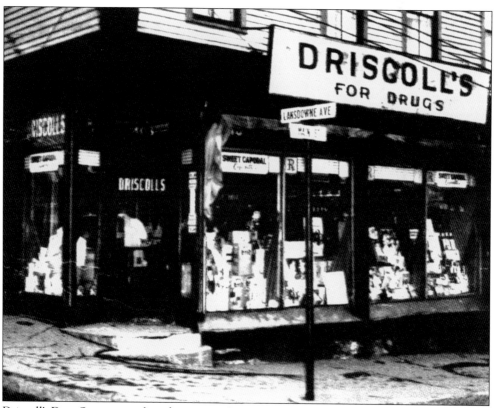

Driscoll's Drug Store opened on the corner of Main Street and Lansdowne Avenue on November 20, 1931, to complement a store on Union Street that had been opened 15 years earlier. Small family-owned stores selling hardware, groceries, and medical supplies were common in the city during the 100 years following the great fire of 1877. They provided a good living for the owners and employed clerks and managers from the surrounding neighbourhoods. This chapter looks at similar businesses, residences, and buildings outside the downtown core.

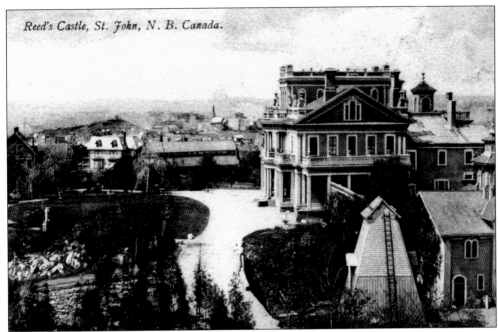

Reed's Castle, St. John, N. B. Canada.

Robert Reed's castle was the finest of many fine homes in Mount Pleasant where many of the moneyed people of the city lived in the late 19th century. Reed built the home about 1852. He loved showing it off and allowed many Sunday school classes to hold picnics in the fine gardens surrounding the house. It was a hotel from 1884 to 1890 and then served as a convent. It burned in 1914.

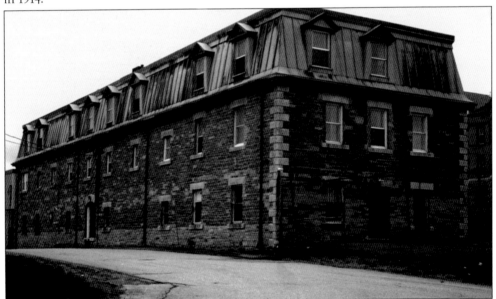

The Sydney Street Ordnance and Armoury Building was built in 1842 to serve the military at Barrack Green. It is the sole remaining British-built structure at Barrack Green. The roof burned off in the great fire of 1877, but the stone building stood and was rebuilt in the Queen Ann style with a mansard roof. It was lengthened in 1911 when the adjacent armoury was built. (Courtesy Harold Wright.)

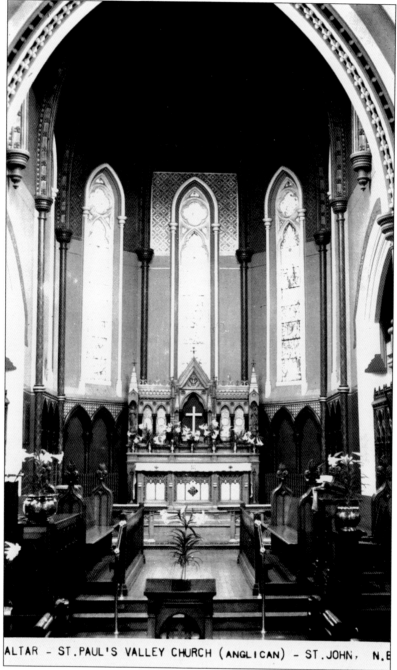

ALTAR - ST.PAUL'S VALLEY CHURCH (ANGLICAN) - ST.JOHN, N.B

St. Paul's Church was one of 13 Anglican churches in Saint John, which reflects the founding Loyalists' faith inclinations. In this case, the church, opened in 1871, served the growing Mount Pleasant area, the city's first suburb. St. Paul's has a fine musical tradition and also had the first surpliced (wearing gowns) choir in Saint John, in 1880. It created quite a furor at the time as it seemed very popish to some of the adherents. Heavily hit by the loss of parishioners due to throughway construction that cut through the parish in the 1960s, the church also suffered from a complete loss of the worship centre pictured here when struck by fire on July 28, 1981.

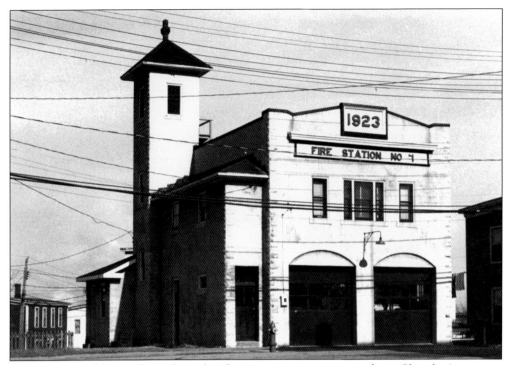

There is no problem telling when this fire station was constructed on Church Avenue in Fairville. It later served as the City of Lancaster's No. 1 fire station while that city existed from 1953 to 1967. During all its years of operation it was beloved by area children as Santa's headquarters at Christmas, when Santa visited and the firemen passed out treats. Today it serves as Hair Station.

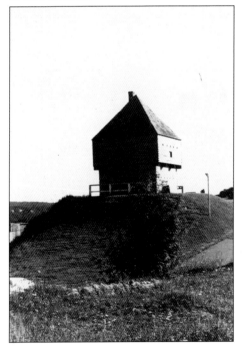

To commemorate Canada's centennial in 1967, the Imperial Order Daughters of the Empire financed the construction of a blockhouse atop Fort Howe. Maj. Gilfred Studholme was in charge of the military fortification atop the hill in 1783 when the Loyalists arrived. No one knows just what that fort looked like, but the current structure serves as a reminder of the story to some degree.

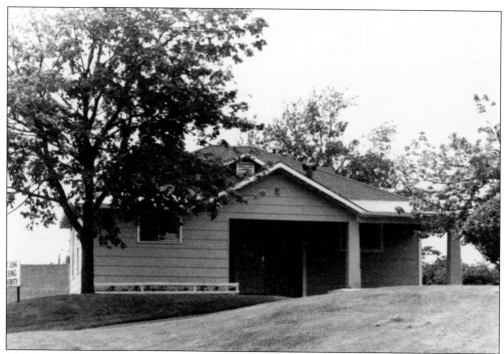

This house began life as a clubhouse for the Portland Golf Club in the city's North End and later served as an administration office of the Saint John Housing Authority when the Rifle Range Assisted Income Housing and Cape Cod–type returning veterans housing was built on the former clubhouse and army practice range following World War II.

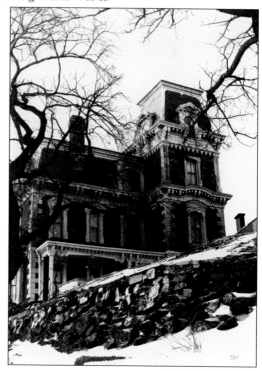

The DeBury house on Main Street was built in 1884 by Count DeBury, who was Belgian counsel for Saint John at the time. It is Second Empire in style and richly adorned inside with trompe l'oeil ("trick of the eye") paintings and fine art depicting Saint John scenes, like Reversing Falls and farther off falls like Niagara. The Count died in 1907; it took to 1960 to settle his estate.

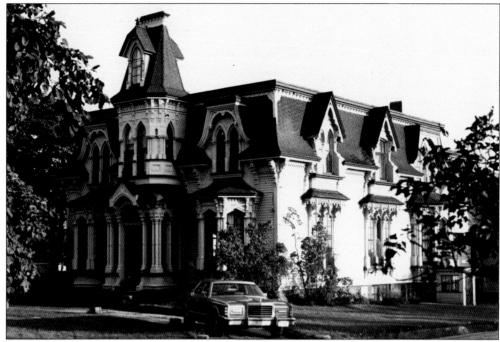

The Earle house is located at 266 Lancaster Avenue, and its lime green, Second Empire Gothic exterior is an eye-catcher for those passing by. It was built by Thomas William Robinson in the 1870s; the Earle family has been there since 1900. After forays in the family Bibles and Persian carpets business, they developed several apartment buildings on the 11.5-acre estate as a more secure financial base.

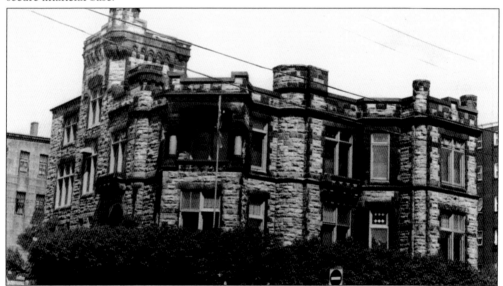

Brewer and one-time mayor of Saint John, Simeon Jones built this Baronial Gothic–style castle on Sydney Street at Mecklenburg in the 1880s. Often called Jones Castle, or the 1880 Club, he officially named it Caverhill Hall in memory of his grandmother. Prime Minister Sir John A. Macdonald and his wife and the Duke and Duchess of York (later King George V) were some of Mayor Jones's guests.

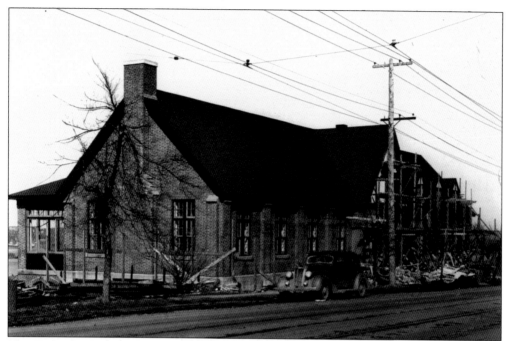

This Tudor-design lodge on Prince Street, west, was a gift to sick and disabled veterans from the Canadian Red Cross in 1948. It was one of 10 lodges constructed across Canada. It overlooked Reversing Falls and stood on Department of Veteran Affairs land, next to the veterans hospital. It had seven bedrooms where families visiting the sick could stay for $1.50 a night, including breakfast. (Courtesy Canadian Red Cross.)

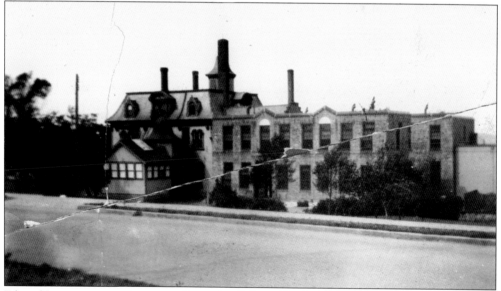

Edward Jewett was a mill owner at Reversing Falls and built this home overlooking the falls. He spared no expense in its construction. It later became part of the veterans hospital. Jewett was not pleased with the change, and his ghost, known as the "Shade of Jewett," created problems until the hospital was torn down in 1994. A veteran kept this torn photograph as a memento of the Jewett Castle.

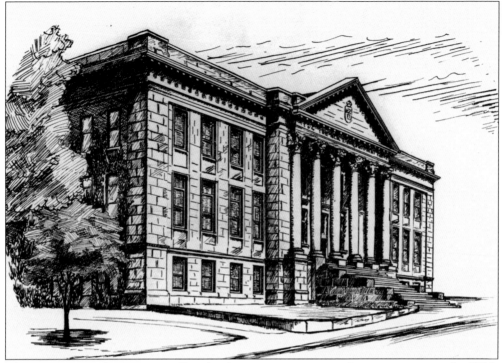

The New Brunswick Museum on Douglas Avenue was constructed to commemorate the 150th anniversary of the founding of the province of New Brunswick in 1934. It is in Saint John, not the capital city of Fredericton, as many imagine it should be, as during the depression only Saint John would offer to cost share the facility. The ornate home it replaced is shown on page 62. (Courtesy Basil Stead.)

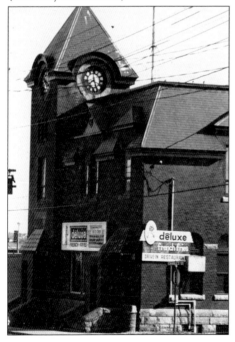

Constructed in 1911, this structure served as the Fairville Post Office until 1971, when it became the home of New Brunswick's best-known french fry chain, Deluxe of Moncton. The ornamental tower clock was one of three in city post offices a century ago. Only one still operates today, and it was moved to the St. George's Church tower from the Union Street Post Office when it was torn down in 1932.

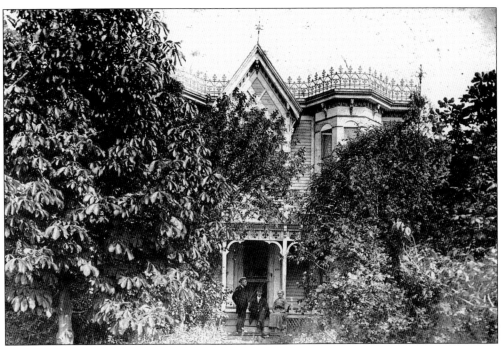

George E. Armstrong built this house at 205 Lancaster Avenue, beginning construction on June 5, 1913. He used plans he paid $5 for from an American firm, Radnor Architectural Company. He finished the home on July 10, 1914, at a cost of $3944.47. This information is all in a notebook he kept showing every item purchased and all tradesmen's wages as he built the home. He did note, "does not include work done by myself." When Hillcrest Baptist Church wished to build on the site in the early 1960s, the house was moved a block south to 37 Buena Vista Avenue, where it stands to this day, owned by Jeff Vale. (Courtesy Florence Armstrong.)

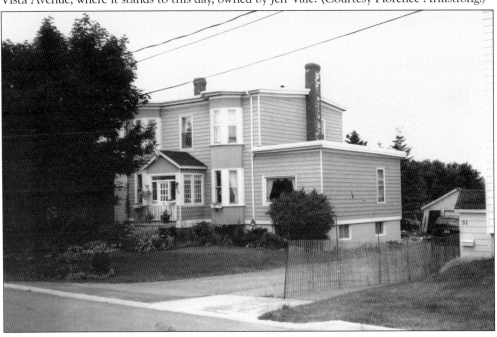

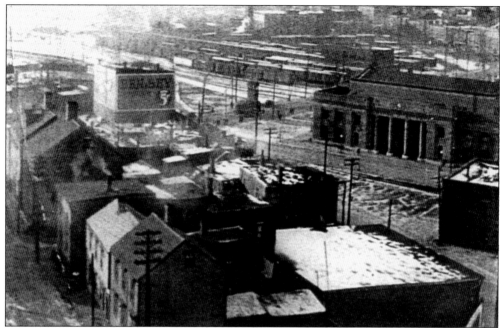

This 1920s north side view of Union Station and the surrounding streets is unique as the foreground shows homes on Pond street that are seldom pictured, the mid picture shows the watchman's gatehouse that controlled traffic on Mill Street, and finally the 5¢ Ben-Gay Cigar sign is shown. Sheds or sides of houses were a popular place to advertise, and few examples of this art remain today. (Courtesy Norm Wasson.)

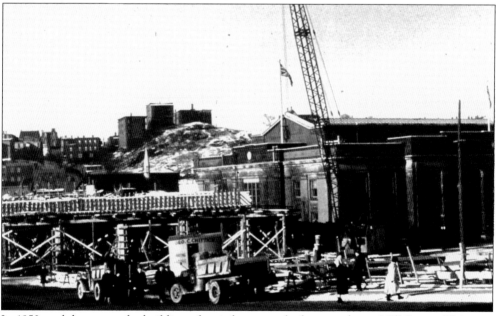

In 1950 work began on the building of a viaduct over the busy tracks on Mill Street. This west end view of the Union Station, with George Chittick's crews at work, was taken when the project was about half complete. Surprisingly, the structure only lasted 20 years, as it proved inadequate as an interchange when the throughway was built in the late 1960s. (Courtesy Harold Wright.)

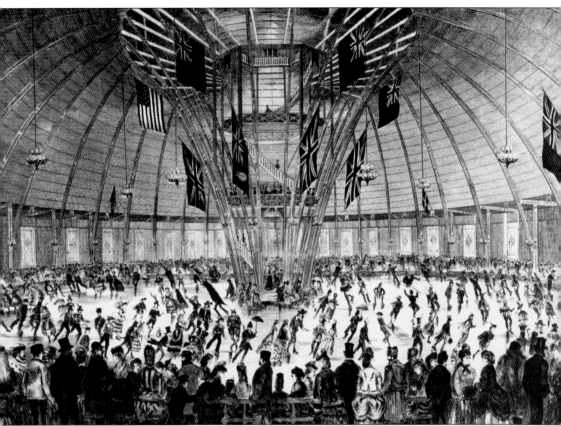

The Victoria Skating Rink was located in the valley between City Road and the rail yard just south of Mount Pleasant. The Colonial Inn (175 City Road) stands partially on the property today. When opened in 1865, the *Scientific American* judged it the peer of all rinks in North America. It was described as "circular form . . . 160 feet in diameter . . . covering 20,000 superficial feet, with an immense dome resting on 20 foot walls pierced with 39 windows." The article noted how the windows would be opened at night from December to March to allow the "crystal floors to be polished and renewed to gleaming by the biting frost." Although Enoch Piper invented the process of freezing salmon by a mechanical process in an adjacent operation, the Victoria never had artificial ice. It was torn down in 1928.

The Thomas Hilyard house at 277 Douglas Avenue was torn down in March 1930 by 55 men in just four days in order to provide all the land needed for the New Brunswick Museum, shown in the lower photograph. When razed, the *Evening Times Globe* report noted, "Real workmanship was discovered . . . the wreckers found every joint in the building was mortised . . . a characteristic of the days when lumber was cheap and labor far less expensive than it is today." Hilyard, a shipbuilder, was long dead by the time his house was taken. The *Saint John Globe* of June 23, 1873, reported "he died at his residence on Bridge Road," the former name for Douglas Avenue, and added, "his death will be regretted by the poor men to many of whom he has given employment." (Above, courtesy Elke Pryor; below, courtesy Ron Cotterell.)

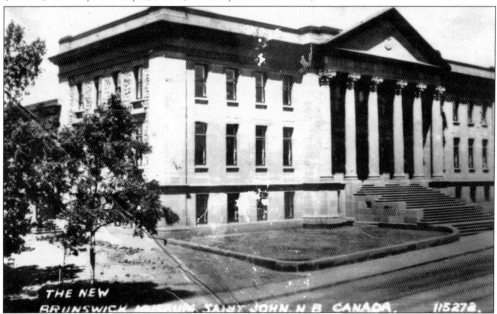

THE NEW
BRUNSWICK MUSEUM, SAINT JOHN, N B CANADA. 115272.

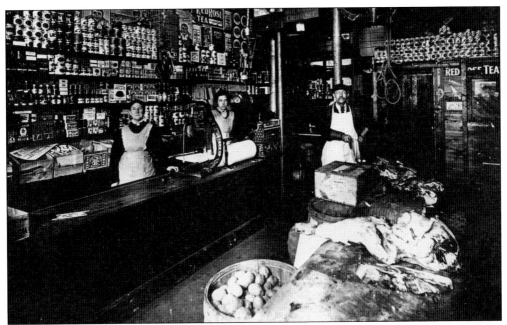

George Morris's well-stocked store was located on Union Street at Winslow Street on Saint John's west side, an area that disappeared with the dock expansion of 1932. Look carefully and note that there are some items for sale in the 1920s-era store like Jell-o, Red Rose Tea, Cow Brand Baking Soda, and Old Dutch Cleanser that can still be found in almost identical packages in stores today. As late as the early 1950s, there were still four dozen family-operated stores in the west Saint John area where the Morris store stood. Today there are less than a half dozen and none as well stocked as the Morris store. Note the Christmas decorations in both photographs, especially the use of greens. It was typical for merchants of the period to decorate elaborately with greenery as a means of drawing in customers. (Courtesy Norm Wasson.)

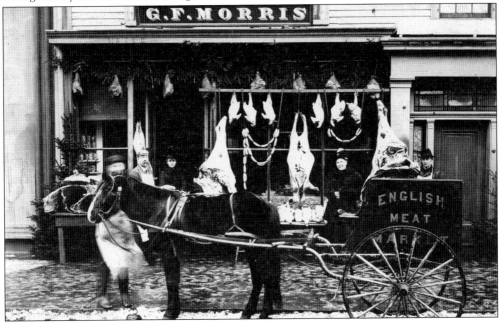

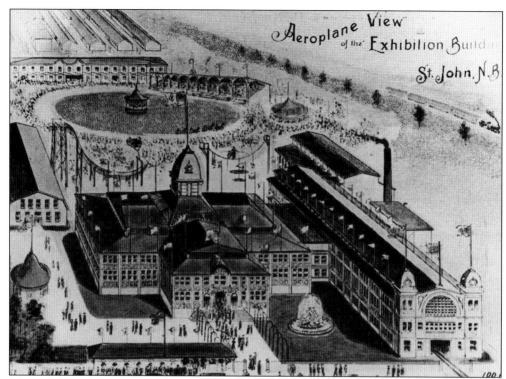

The exhibition grounds were originally located off Broad Street in South End Saint John. Following the success of the Crystal Palace exhibition in 1853, communities everywhere built ornate exhibition buildings in which to stage demonstrations of the latest in goods and services the community offered. For years, it remained the best way to show off the community's assets, as well as to give patrons a chance to enjoy rides, sideshows, and entertaining acts. The lower photograph shows the interior of the pavilion in the upper photograph, and the year is 1899 when the Edison Company was promoting its newest in electrical ideas with dynamos and other apparatus, but do note the building is still lit with gas lamps. The city's leading department store, MRA, has a huge presence too. (Below, Provincial Archives P37-1.)

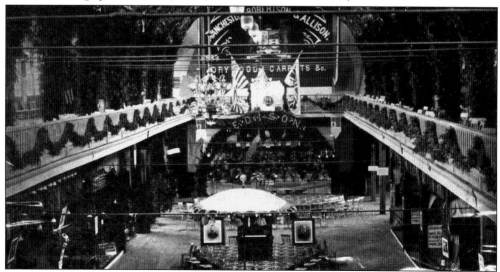

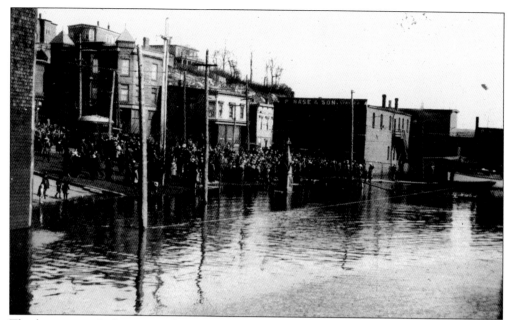

The business at Indiantown, about 1930, where Main Street met the Saint John River, was largely dependent on the riverboat traffic from that river. Passengers would be coming and going steadily during the riverboat season, roughly April through November. However, in the spring of the year when the melting snow swelled the river, those businesses could find themselves with up to two feet of water in their Bridge Street stores. (Courtesy Norm Wasson.)

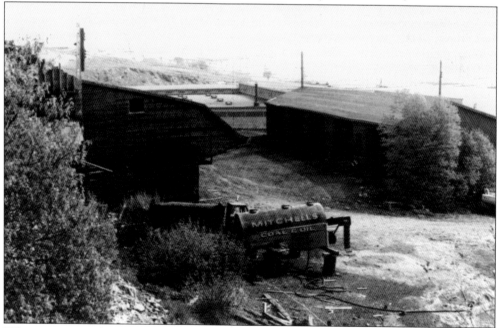

When constructed in 1948, the Parker D. Mitchell coal yard on Merritt Street could handle 10 railcars at once. The business began in 1928 with a small shed and a single horse and wagon in west Saint John. By 1979, when this photograph was taken, coal is all but phased out, a thing of the past, but the shed, winches, and sorting machinery are still in the yard.

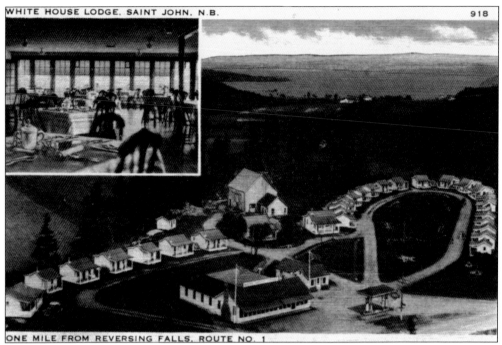

ONE MILE FROM REVERSING FALLS, ROUTE NO. 1

The White House Lodge in Saint John West is said to have been the first rubber tire hotel established in the Maritimes. It benefited from being on the principal route most Americans used to come down east. As they traveled up highway 1 from Calais, Maine, the White House was the first lodging they would meet on the outskirts of Saint John. It opened in 1938, owned by A. D. Biggs, and the postcard view would be from that era. The Maguires Steak House took over the restaurant operation as the facility aged, and it ceased to be in 1993. The name lives on through garden house development, where the principal street is called White House Court.

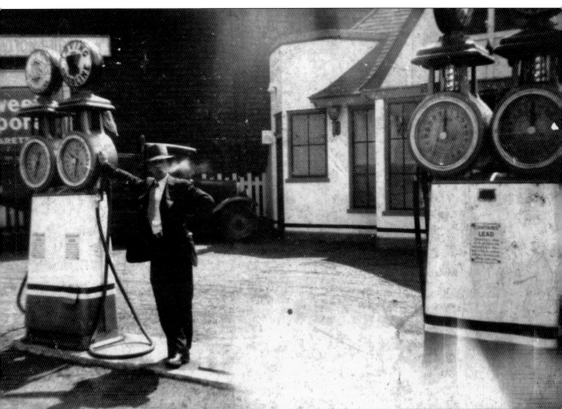

All traffic coming into Saint John from the east had to pass through Haymarket Square, and, of course, the gas station owners soon took advantage of a captive audience and competing brands set up stations on both sides of the bridge over the Marsh Creek. In this photograph is a very casual approach to selling gas where the attendant is taking a break from his duties and enjoying a cigarette a bit closer to the pump than would be advisable. This is likely Joe Patchell's station, one of two he had, the first being on Douglas Avenue at Falls View Drive, which was the first service station established in the city in 1922. (Courtesy Norm Wasson.)

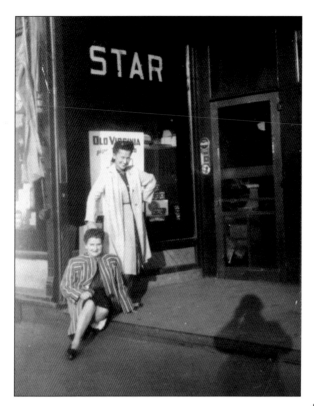

The ladies standing outside the Star Ice Cream Parlour on King Street, Saint John West, are Judy Koven (left) and Marion Saunders in this photograph provided by Esther Koven. Sydney Koven opened the popular restaurant, ice-cream parlour, magazine store, and cigarette shop in 1942. It was the place for young people to be seen on the west side in the 15 years it existed. It burned in November 1957. (Courtesy Esther Koven.)

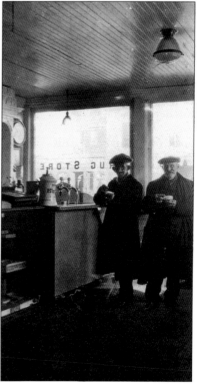

Across King Street from the Star was Ingraham's Drug Store, where the two unknown gents are enjoying a root beer poured over a cup of shaved ice, a specialty of the shop, and likely talking with owner E. R. W. "Duphie" Ingraham. Ingraham was a popular figure in the community and well known as another Mason. His photograph hangs on the walls of the Charlotte Street Masonic Lodge, the second oldest lodge in Canada. (Courtesy Carolyn Kindred.)

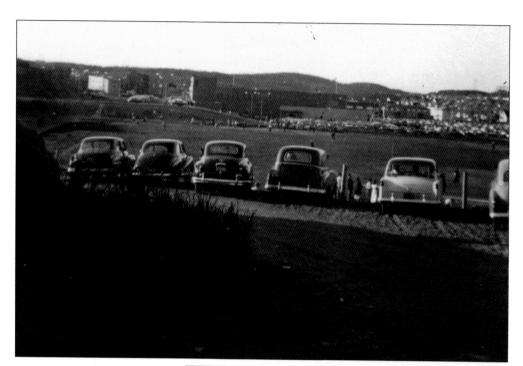

Shopping began to change in Saint John with the opening of Sears in the Fairview Plaza, Saint John North, in July 1955. This photograph shows cars ringing Shamrock field, which disappeared in the mall's development, on the day Sears opened. None of them likely knew that this development was the beginning of the end for the home owned and operated stores that dotted their neighbourhoods. Soon after Sears, in July 1965, KMart came into the city on the west side at the Lancaster Mall, and in February 1970, Woolco, pictured here, became the anchor merchant of the Loch Lomond Mall on the east side. (Above, courtesy June Malloy Prebble; right, courtesy Saint John Energy.)

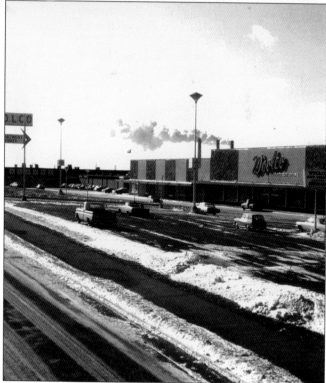

After years of little change in the built structure of the city, both private and public sectors were involved in the changes that came to Saint John through the 1960s and 1970s. The top photograph shows the Telegraph Journal, Evening Times Globe building under construction in November 1962. It moved from the heart of the city, Canterbury Street, to the heart of the urban renewal area around Courtenay Bay, and this allowed new presses and operating efficiencies for the Irving-owned company. In the lower photograph, a community centre is being added to Lorne School in the North End of the city in January 1979. Both of these changes made sense, thus, both are still operational. (Above, courtesy Saint John Energy; below, courtesy City of Saint John.)

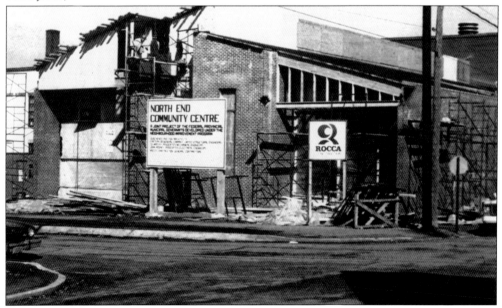

Four

HARBOUR VIEWS

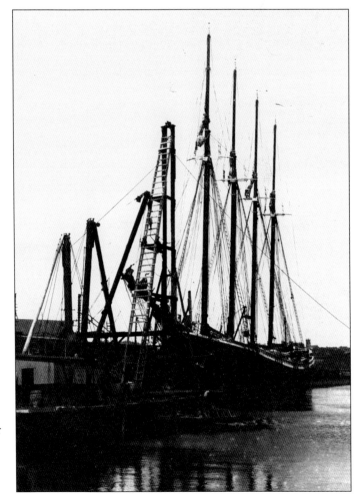

It was the cutting of timber and the building of tall ships, like this one pictured at Colwell's Coal shed, on which Saint John's economy was based in the 19th century. Just as the shipbuilding era was coming to an end the mid-city burned in June 1877. Many unemployed shipbuilders found work rebuilding the city. In 1896 Saint John was chosen by Canadian Pacific as Canada's winter port, and thus the harbour continued its important commercial role, which is depicted in this chapter. (Courtesy Ian Hamilton.)

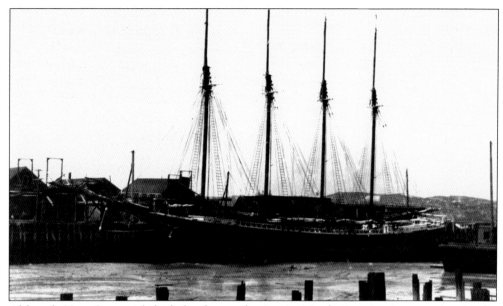

Although New Brunswick had the first coal mine in North America in operation in the Minto-Chipman area there was still a great need for imported coal, especially for the power plant on page 41. It burned coal from Cape Breton. As wooden ships were phasing out, it was still economical to use them for coastal trading for bulk commodities, including coal, lumber, and gypsum. (Courtesy Ian Hamilton.)

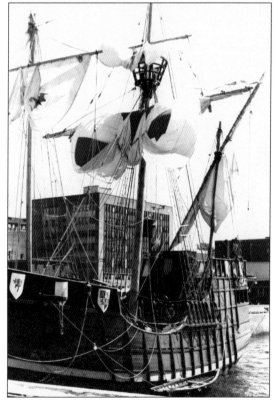

Christopher Columbus did not sail into Saint John, but a replica of his ship the *Santa Maria* did in September 1971. A Portuguese explorer, Estevan Gomez, is thought to have visited the area in 1525. This is based on maps drawn based on his exploration of the entire east coast on which was noted a river that reversed, which could only be the Saint John at the Reversing Falls.

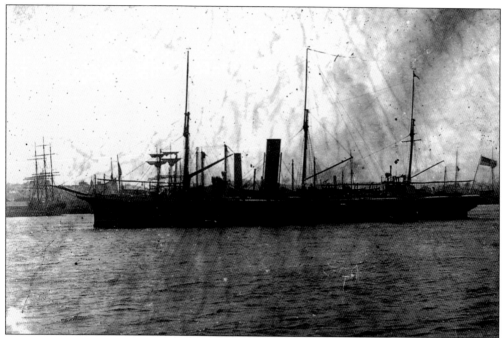

This unidentified vessel in Saint John Harbour is a steamer but still has sails, as there were times when they helped speed up a trip. Also with early steamers, coal needs were sometimes misjudged and fuel ran out, but wind seldom failed. The photograph can be dated to the 1880s, the period when the transition from sail to steam was in full swing. (Courtesy New Brunswick Historical Society.)

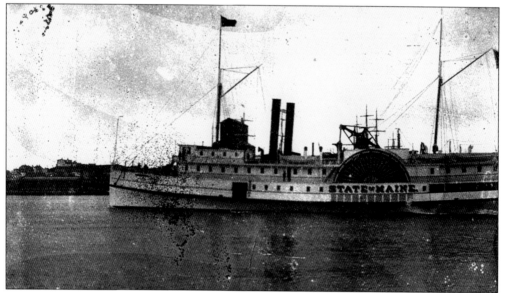

The *State of Maine* was one of several vessels of the International Steamship Line that linked Saint John and Boston. Built in Maine in 1881, it made its first trip to Saint John on August 3, 1882. Over 1000 people turned out to visit her while in port. She was described as a "noble specimen of naval architecture" and "a palatial home" for her passengers. (Courtesy New Brunswick Historical Society.)

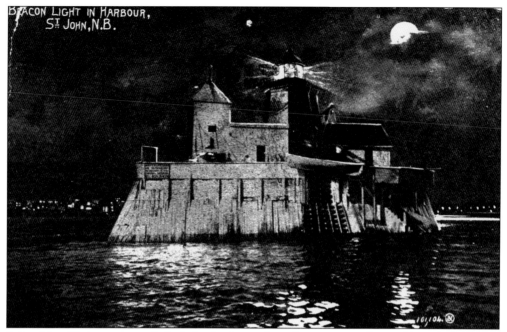

Saint John Harbour not only had the highest tides of any city in the world to deal with at 28 feet, but there were many rocky formations below tide line that were hazardous. One ledge off Beatteay's Beach was protected by the Beacon light beginning in 1828. It was purposely burned to below tide line in August 1913, when it was no longer considered an aid to navigation but a hazard.

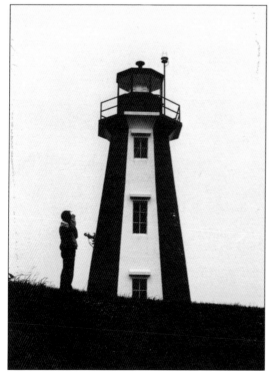

Another aid to navigation in the harbour is the light on Partridge Island, which dates from 1791 and was the third lighthouse established in Canada. The current light was built in 1959; it is the island's fourth and is still in use, although not manned. Another feature of the island was the world's first foghorn, placed there by Robert Foulis in 1859.

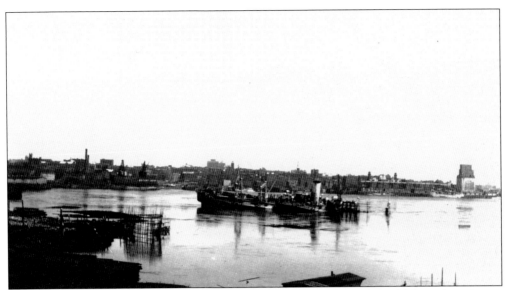

However, all the navigation aids in the world are still sometimes trumped by Mother Nature. In the top photograph, the *Beaverhill* has sunk on the Hilyard's Reef in the inner harbour in November 1944. Loaded with ammunition for overseas, there was the potential for a catastrophe, but fortunately it did not occur. In the lower photograph, the *Manes P* is snug against the Partridge Island breakwater in February 1970, the victim of a wild winter storm. Both vessels were a complete loss. Fortunately, such occurrences are rare in the harbour. (Above, courtesy Florence Armstrong.)

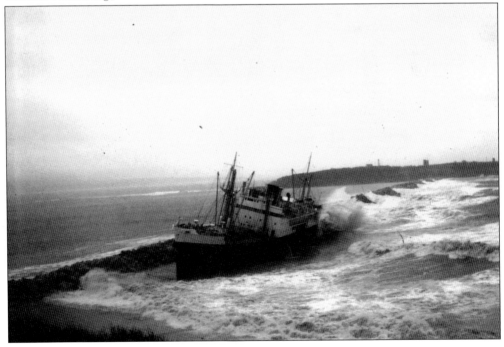

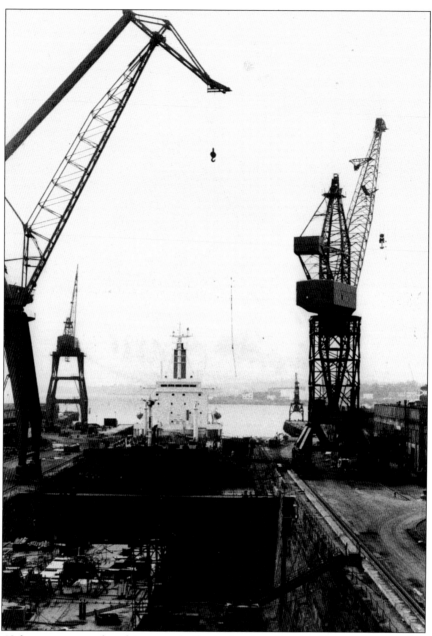

In the 19th century, wooden ships were built on the shoreline in almost any area where they could be easily launched. In 1875, for instance, there were 17 shipyards in Courtenay Bay alone. With steel ships, a dry dock was required, and Saint John had one of the largest and best equipped in the world. This was the Saint John Shipbuilding and Dry Dock on Bayside Drive, opened in 1923 and operational until 2002. When opened, it could accommodate the largest ship afloat, at that time the 956-foot *Majestic*. It was built by an English firm Norton Griffiths, and the Irvings were the last owners. While they tried valiantly to keep the shipbuilding tradition alive, it proved impossible to compete against low-wage countries despite the great technological advances that were made in the last major project, the building of a fleet of 12 frigates in the 1980s and 1990s.

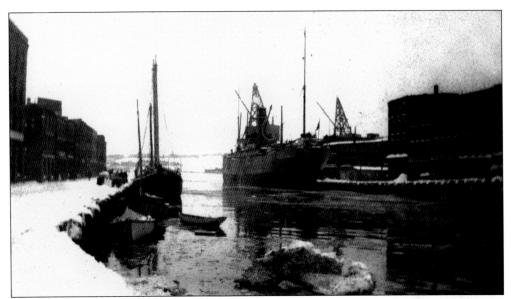

Initially all sea-based cargo came into Saint John and was landed at Market Slip, shown in the top photograph. Goods would be transferred from the ship as they lay on the mud at low tide and stored in the warehouses atop the wharves until transshipped inland, by horse and wagon, riverboat, or rail. In the lower photograph, Market Slip and the harbour are seen from Fort Howe. In the middle of the photograph is Pugsley Wharf with sheds, now demolished, and the area used as a cruise ship terminal. Behind Pugsley Wharf is the CN (Canadian National Railway) grain elevator and beyond that the Atlantic Sugar Refinery. Both have been demolished.

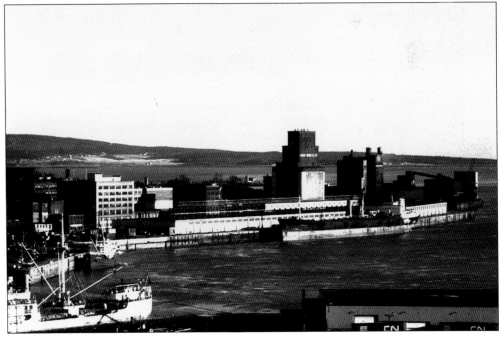

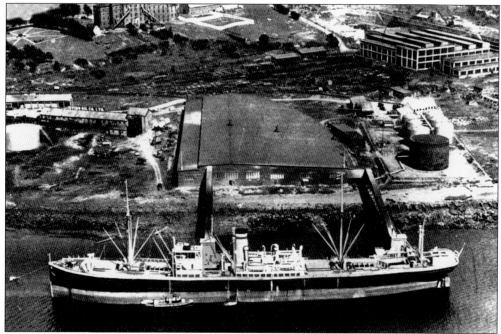

This calendar shot of the SS *Torrhead* was done to promote the new Saint John east fertilizer plant in December 1931. Note the Irving Oil tanks on the left. Irving had just begun operation in the city at that time. Behind the huge fertilizer plant is the poorhouse, with an adjacent cemetery. On the right is a portion of the Saint John Shipbuilding and Dry Dock. (Courtesy Harold Wright.)

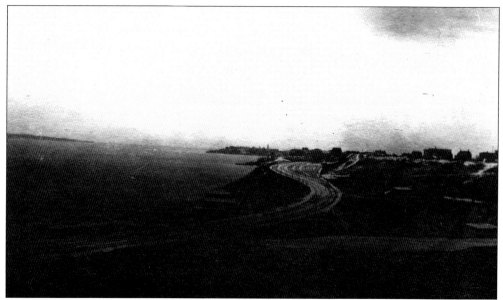

Saint John West benefitted most from the selection of the city as the eastern terminus of the Canadian Pacific Railway and Canada's winter port in 1896. The goods coming in by ship required the laying of many more tracks leading from the west side docks to the main lines of the railway to Montreal. Shown is a portion at Beatteay's Beach, with Partridge Island clearly showing in the background. (Courtesy Norm Wasson.)

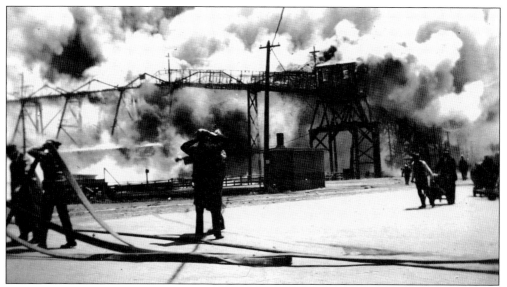

On June 27, 1931, a devastating fire stuck the docks of Saint John West that were so essential to the winter port operations. A total of $10 million in damage was done. Although a disaster of epic proportions, it also proved beneficial, for much work was created in the depression era for Saint John men, and the city ended up with upgraded port facilities that served well for years to come. (Courtesy Florence Armstrong.)

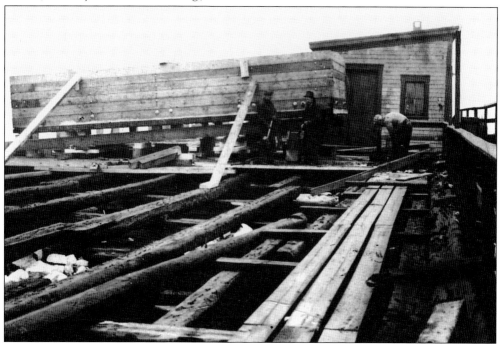

Like many Saint John West residents, Sandra (McArthur) Wright's father worked at the port. In an unusual move, in 1941 he took a series of photographs showing his crew at work rebuilding what he called the "Glenbuckie wharf." Number eight in the series described the work as "Skids raised up and blocking put underneath. Hardwood 1" boards to underside." (Courtesy Sandra Wright.)

When almost 100, Maebelle Mellenger shared this painting her mother did of Navy Island in Saint John West in 1898. At that time, the island in the mouth of the harbour was favored by fishermen who worked the water for gaspereau, shad, and salmon. It is now gone, taken in part for port expansion in 1932, and finally disappearing with the Harbour Bridge construction in 1968. (Courtesy Maebelle Mellenger.)

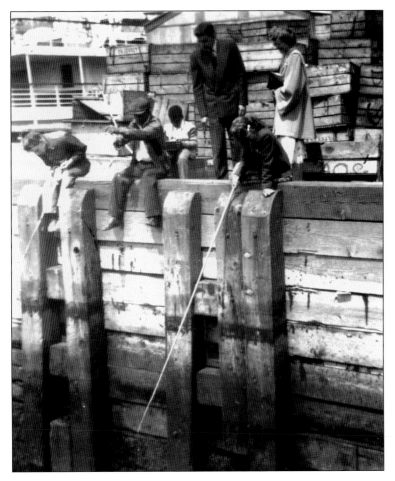

Fishing is seen off Reed's Point in the South End of Saint John, where the steamers from Boston noted on page 73 docked. Mackerel, smelt, and tomcod were the most oft caught specimen, but even if nothing at all was caught, it was a great way for fathers and sons to pass an evening. (Courtesy Norman Wasson.)

Five

REVERSING FALLS

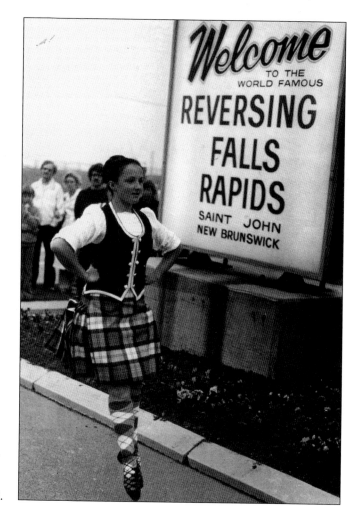

A highland dancer greets visitors at Reversing Falls, which is both the city's best-known and least-understood natural phenomena. It is where the 750-kilometer (450-mile) Saint John River tries to enter the Bay of Fundy in Saint John Harbour via a 200-meter (600-foot) gorge. This created a mighty battle between river and bay in trying to overcome the 9-meter or 28-foot tides pushing against it. It is all very mysterious and must be seen at all three phases, high tide, slack tide, and low tide (shown in the photographs that follow) to be appreciated.

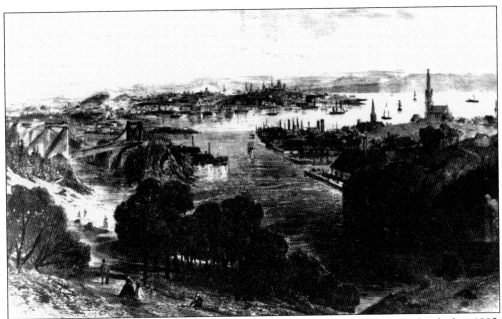

This lithograph shows the falls after 1853, when the bridge pictured was built, but before 1885, when a railway bridge was built to the north of the bridge. The pathways in the foreground were on Hamilton's Hill, or Avery's Grounds, names given to the grassy area west of the falls. After 1848, it became a garden for the asylum that stood on the hill from where this sketch was made.

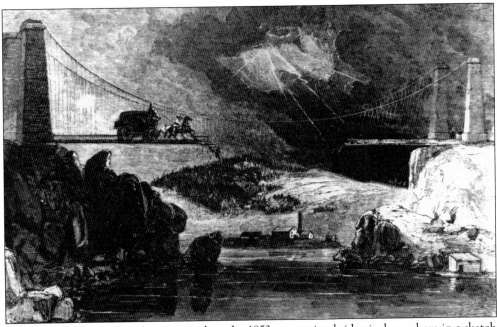

The most famed incident that occurred on the 1853 suspension bridge is shown here in a sketch from *Harper's Weekly* of May 1, 1858. It depicts the attempted crossing of a stagecoach from Fredericton on the night of March 24, 1858, when 100 feet of the bridge was destroyed by a wind and lightning storm, and the horses had sense enough not to proceed, thus saving many lives.

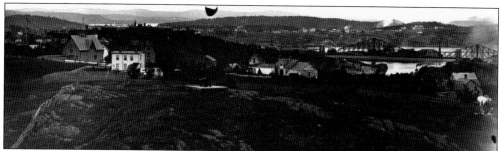

When Hans Gustavson (pictured here) came to visit the Biermann family at their home overlooking Reversing Falls, the view shown of the falls is what he saw, but the bridge is not the one he crossed to get there in the 1920s. In 1915 a new 565-foot bridge was built over the falls, and the suspension bridge was dismantled. (See page 84). Gustavson visited often, but stayed only once overnight with the Biermanns, as he claimed to have been awakened at night by a headless lady menacingly rocking beside his bed. (Courtesy Helmer Biermann.)

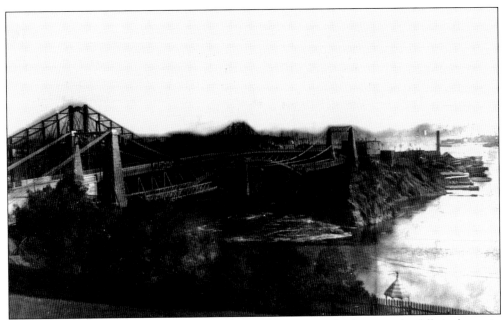

The process of dismantling and removing the 1853 suspension bridge over the falls is shown in these two photographs in August 1915. The house Hans Gustavson had the ghostly experience in is seen on the ridge to the right in the lower photograph. Pieces of the 10 cables (each with 3500 strands) from the bridge were snapped up by spectators as souvenirs of the first successful bridge to join central and west Saint John. The bases of the 52-foot piers on which the cables were supported are still in use to this day. On the west, they support a portion of the tourist bureau; on the east, they are used as an observation post on the Harbour Passage trail. (Courtesy Norman Wasson.)

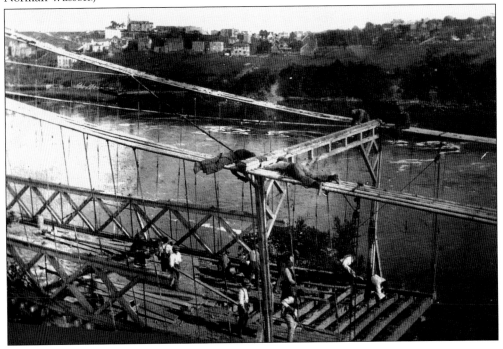

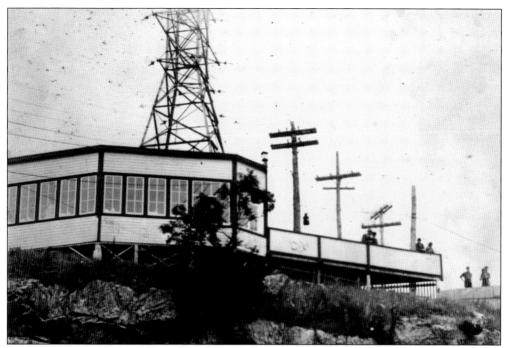

The earliest attempt to display the falls for visitors, mostly in cars from the eastern United States, was via a tourist hut established in 1930. Seven hundred visitors came in July of that year. During the war years, it also served as a popular dance area for servicemen. In the early 1950s, as pictured here, it was called a trading post and offered food as well as advice.

In 1953 the province of New Brunswick offered to cost share with the City of Lancaster and the City of Saint John to undertake the building of a $45,000 Twin City Trading Post to replace the structure in this photograph. Note the ability to "fill up the tank" after filling up the stomach on food prepared by the operator, J. M. Robinson, and his wife. In July 1953, 12 000 visited the site.

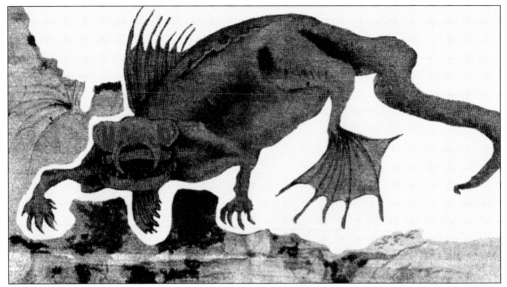

In 1951 a painting of the Ug Wug by artist Isabel McGuire was done on the walls of the trading post. It proved so scary patrons would not come in to eat, so it was soon covered by Gyproc. The Ug Wug legend goes back to the native era. They avoided the falls due to its whirlpools and rapids, said to be created by a monster. (Courtesy Harold Wright.)

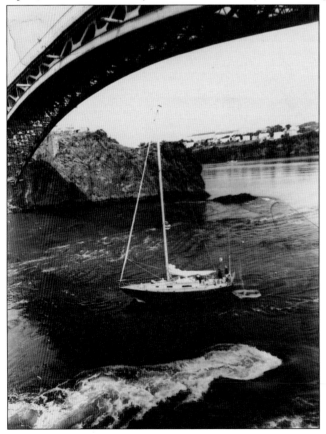

American fleets of sailboats come regularly to enjoy the scenic Saint John River, often called the Rhine of America. In order to get to its placid waters, they have to pass through Reversing Falls at slack tide as is being done in this photograph. (Courtesy Tourism Saint John.)

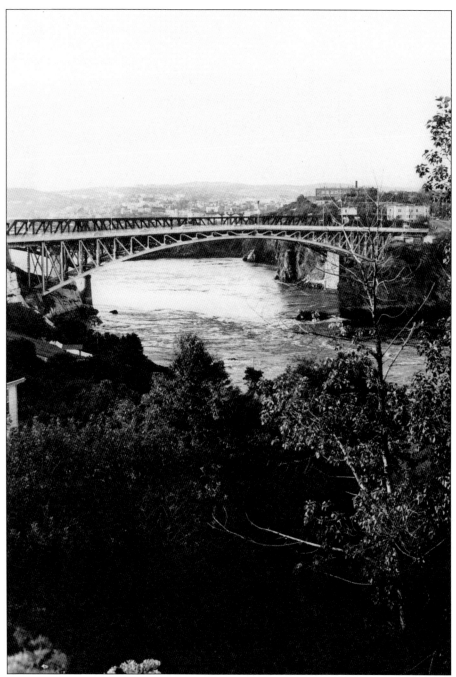

Reversing Falls is seen in 1978. It was in 1928 that it was first proposed that the falls be floodlit at night. It did not happen, though, until 1955. In 1913 Rodman Law proposed being hung by a rope dangled from the bridge directly over the biggest whirlpool, called the "Pot." He was to be filmed doing the stunt, so it could be shown as a feature at the nickel theatres that had sprung up across the land. However, when he stood on the bridge and observed the action of the falls, he demurred. Frank Martin, however, was braver. He swam through the falls in 1958 and on at least four other occasions in his lifetime.

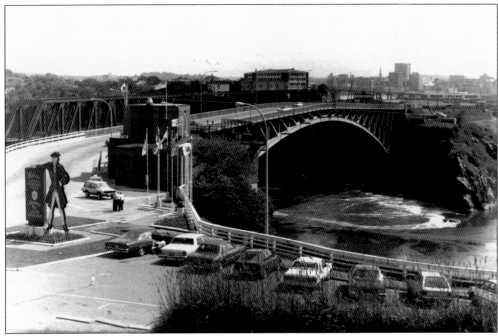

In this photograph, the falls are reversing. The high tides of the Fundy are pushing the water upstream contrary to the natural flow of a river. This is best seen in the current around the rock under the bridge, known as Split Rock. According to native legend, it is the club their great god Glooscap used to break a huge dam a big beaver had built across the mouth of the river.

The final photograph of this chapter shows the falls at slack tide. Note the millpond stillness as the river and bay are at equal height and strength. In the foreground is the Wharf Museum, a short-lived development of Ralph Bangay in the late 1970s to show off his collection of nautical artifacts. The tugboat *Mohawk 11* and the *Ocean Spray*, a Newfoundland dragger, were part of his collection.

Six

ROCKWOOD PARK

Agitation for a public park for Saint John's Mount Pleasant area had begun in the 1860s, when a *New Brunswick Courier* column described the area as being free from "dust and din," with "untainted air" and plenty of "nature in all its romantic loveliness" as being among its attributes. The park became a reality in 1894. It has had several phases of development, and this chapter shows that. The photograph on this page depicts work at the Fisher Lakes in December 1966. (Courtesy Saint John Leisure Services.)

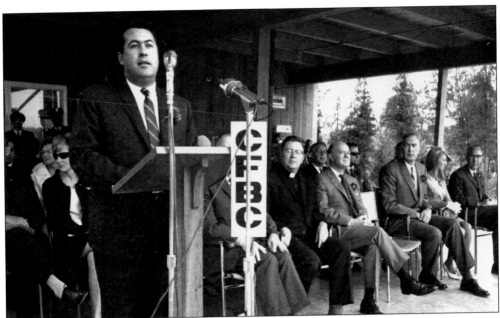

The Honourable Bill Duffy is shown at the CFBC microphone in July 1967 at the official opening of the Fisher Lakes, which had been redeveloped at a cost of $250 000 as a centennial project of the recreation department. Others present include Mayor Joseph MacDougall, fourth from the left, and City Manager Stan Price, fifth from the left. Others remain unidentified. (Courtesy Saint John Leisure Services.)

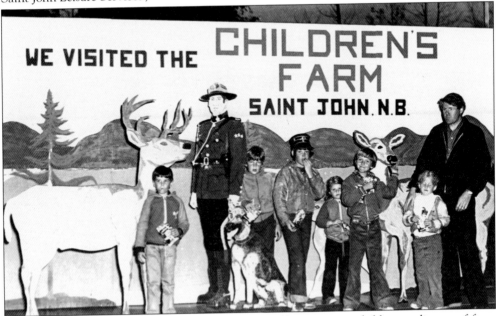

Among the 1967 projects was a children's farm to offer inner-city children a glimpse of farm life. There were horses, cows, pigs, sheep, and so on as domestic examples. In addition, there were wild creatures, including a wolf, whose pacing bothered many, and skunks, who many avoided, and deer, ducks, owls, and raccoons. Aubrey Cox made the welcoming panel to the area. (Courtesy Saint John Leisure Services.)

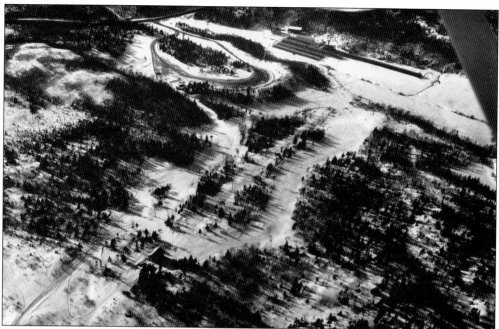

Another new addition to Rockwood in 1967 was a ski hill operation off the Sandy Point Road. It had a T-bar for pulling skiers to the hilltop, a modest 125 feet, and four slopes, none very challenging, but as there were no other options in Saint John for skiers, it seemed a good investment at $80 000. When there was snow, it was a busy spot (as seen here), but there were winters when it only ran a few days due to Saint John's climate. There was a primitive snow-making machine, but it was expensive to operate, and often a snow cover would be washed off by rain. The hill had to be set up each fall and dismantled each spring due to vandalism potential, which added to the high cost of operation. It ceased to run in 1988. (Courtesy Saint John Leisure Services.)

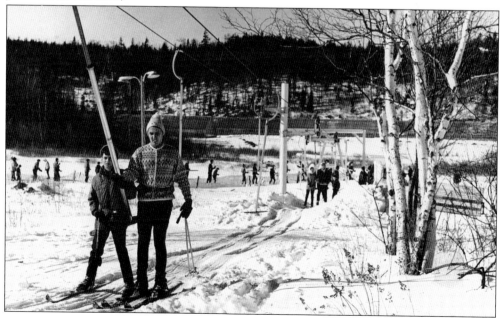

Draft horses, which were part of the children's farm attractions, and sometimes used on city streets (see page 128), were used in summer in Rockwood to pull a tally-ho wagon to move patrons from one part of the park to another. In winter the tallyho was equipped with skis and began a sleigh ride. It proved a popular addition to the park. When the dozen or so senior citizens groups held their winter gathering at the Lily Lake pavilion, a sleigh ride was one of the highlights. Seen here is senior Billy Godsoe chatting up two of the four horses used for this operation. (Above, Saint John Leisure Services.)

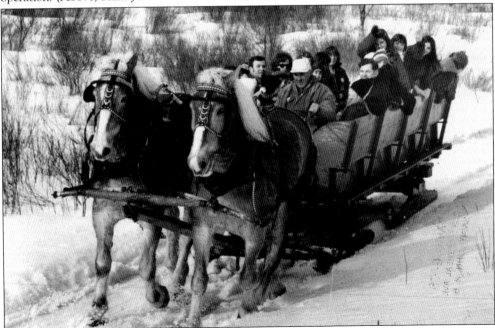

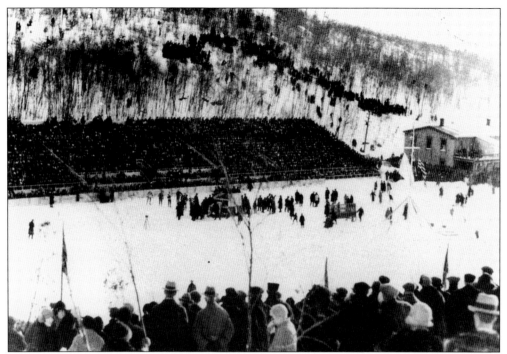

Although large crowds came to enjoy the park's attractions after the 1967 redevelopment, there were never the numbers that showed up at Lily Lake on February 7, 1926, when city native Charlie Gorman came from dead last in a five-mile race to lead the field at the finish line. The crowd was estimated to be 26 000 strong. Some of Gorman's records still stand.

In 1899, and again in 1967, it was recommended that the city establish a golf course as part of Rockwood's attractions. It did not happen until 1971, when a nine-hole course was built on Sandy Point Road, which was gradually expanded to the regulation 18 holes over the next 20 years. It continues to operate to this day under a concession arrangement.

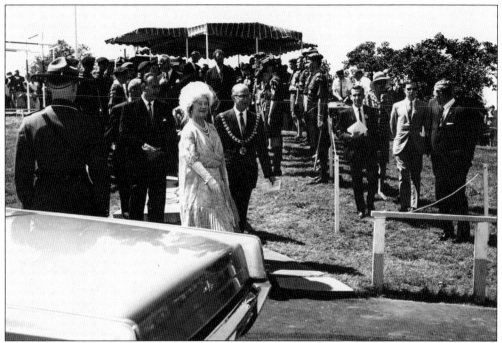

Rockwood has many oak trees said to have come from Buckingham Palace grounds, thus called Royal Oaks. That may be just a story, but a royal visit to the park was made in July 1967, when the Queen Mother, with Mayor Joe MacDougall, walked over a pad of grass where a plaque commemorating Lily Lake as the city's first water supply had been erected. (Courtesy Saint John Leisure Services.)

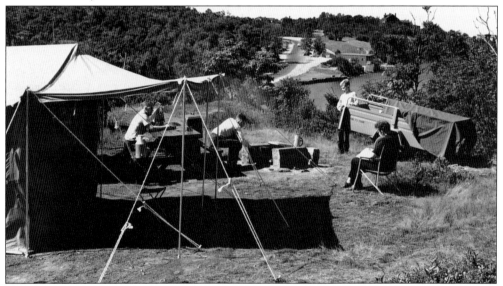

In the early 1950s the Provincial Government recommended the Horticultural Association close the zoological grounds in the park and convert it to a campground. A zoo had existed almost from the 1894 beginning and had been a delight to many but was in sad shape by the 1950s. Thus the advice was followed, and the campers appearing here about 1975 came to enjoy the new campground. (Courtesy Saint John Leisure Services.)

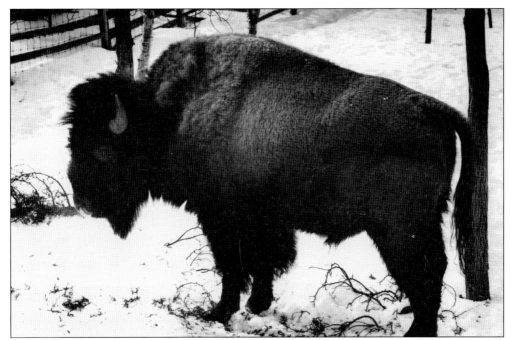

The children's farm established in 1967 was a hit with Saint John families. One of the more unusual animals was Doug the buffalo, a gift of the Milton, Ontario, Halton Region Conservation Authority in December 1969. Initially weighing 500 pounds, by November 1972 he had gained 1200 pounds and a mate, Muriel. Sadly, Doug escaped and was shot in July 1973, and Muriel died soon after. (Courtesy Harold Wright.)

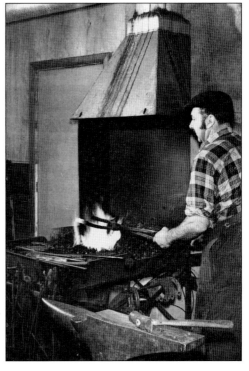

After Rockwood Park's redevelopment, there were some busy years in the late 1960s and through the 1970s when there was enough shoeing demand along with related metalwork that a blacksmith set up operations in the park and was, for some time, a city employee. His name was Walter "Harry" Hodkinson, and he came all the way from England to work in the park. (Courtesy Saint John Leisure Services.)

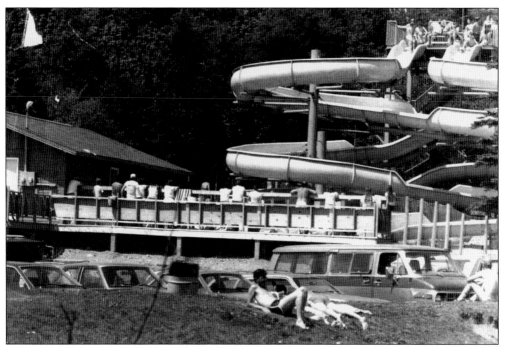

Not every new idea tried out in the park has worked out, including the two shown on this page, a bumper boat and minigolf operation and a water slide feature. Both were near the Fisher Lakes, but neither was in the most traveled zone of the park. That, combined with foggy days, and a shorter summer season than inland locations were factors in the demise of these two attractions.

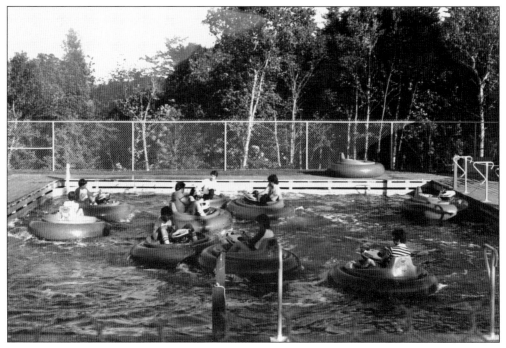

Surprisingly, the Downing Vaux report on what the Horticultural Association had done in 1899 in order to improve on the work they had already done on trails, roads, lookouts, and so on did not mention swimming as a suitable park activity. At the time, it was considered healthy to "bathe" in the ocean, and there were several bathing beaches in Saint John where the cold water of Fundy was considered a tonic. Early lake activity seems to have favored rowing competitions, mainly sponsored the Neptune Rowing Club. By the 1970s, these competitions also featured "round the lake swims," usually as part of the Loyalist Day Festivals, and that is what is shown in the photographs on this page. (Courtesy Saint John Leisure Services.)

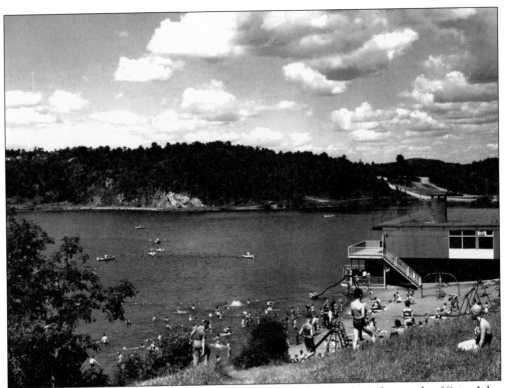

My mid-July 1894, the *Daily Telegraph* was able to note of Lily Lake that "the people of Saint John are now taking advantage of the opportunities of enjoying the pleasures of rural life without going outside the bounds of the city." They still do, as seen in these contrasting seasonal photographs of Lily Lake and the 1951 pavilion, which has been refurbished in the past few years and is now known as the Hathaway Pavilion. (Above, courtesy Saint John Leisure Services.)

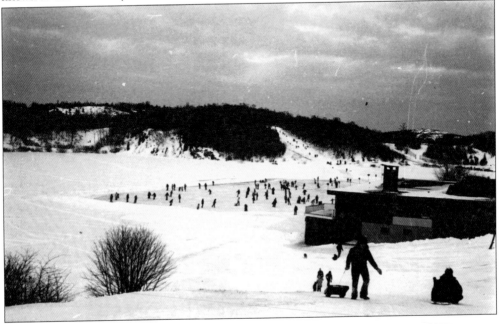

Seven

PUBLIC EVENTS

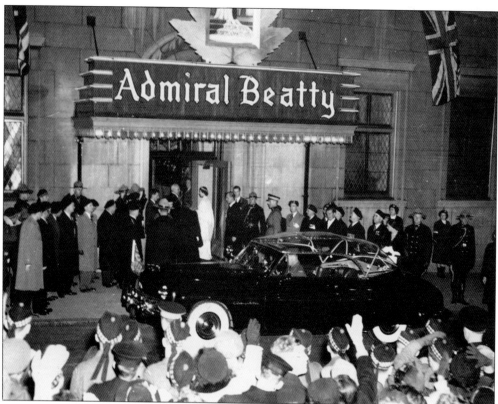

Public events are the lifeblood of any city. This chapter provides a glimpse of a few of the activities that have drawn the public to the streets, squares, and public places so they may see some inspiring or talented individual or be part of a public spectacle themselves. One such event was on November 6, 1951, when Princess Elizabeth was about to pass through the main doorway of the city's leading hotel, the Admiral Beatty, to attend a reception. (Courtesy Norm Wasson, a Climo Studio photograph.)

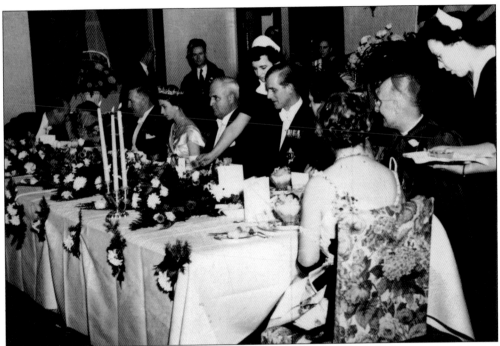

The official banquet honouring Princess Elizabeth and her husband, Phillip, at the Admiral Beatty is pictured here. The special guests are, beginning at the left of the table, Hon. Milton Gregg, Alice Howard, Lt.-Gov. D. L. MacLaren, Princess Elizabeth, Mayor George Howard, Prince Phillip, Dorothy MacLaren, Bishop P. A. Bray, and Amy Dorothy Gregg, with her back to the camera. (Courtesy Norman Wasson, a Climo Studio photograph.)

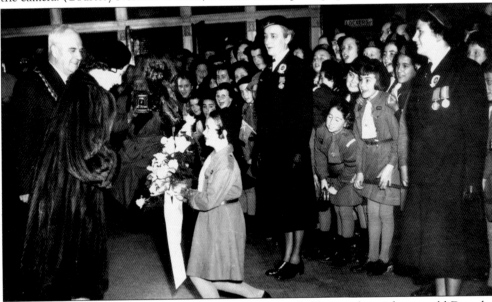

Greeting Princess Elizabeth at Union Station (they traveled by train) is eight-year-old Dorothy Ann Dakin, of 74 St. James Street, on behalf of the Girl Guides of Canada. The two Guiders are Lois Rolph (left) and Helen Burke (right). Note the delight in the eyes of the young Guide between the two Guide leaders. (Courtesy Norman Wasson, a Climo Studio photograph.)

When the circus came to Saint John, it always held a preview parade to entice customers to come to the circus grounds. Of all the creatures paraded through town, Jumbo the elephant was likely the most famous. He visited the city on July 6, 1885, and it was his first appearance in Canada. Two months later, he was dead, killed by a train in St. Thomas, Ontario.

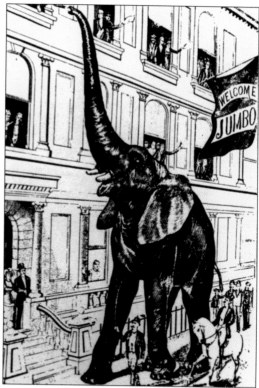

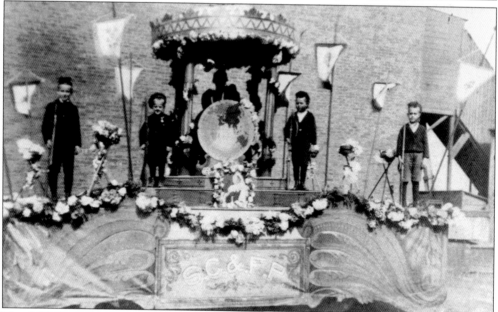

The SC&FP (Salvage Corps and Fire Police) float was built to mark the 60th anniversary of the reign of Queen Victoria in 1897. Royal occasions were always marked in Saint John with parades, bonfires, fireworks, special church services, military reviews, and so on, as the city had a very strong business link, and through this a social link, with Britain as a result of shipbuilding and the lumber trade. (Courtesy Rowan collection.)

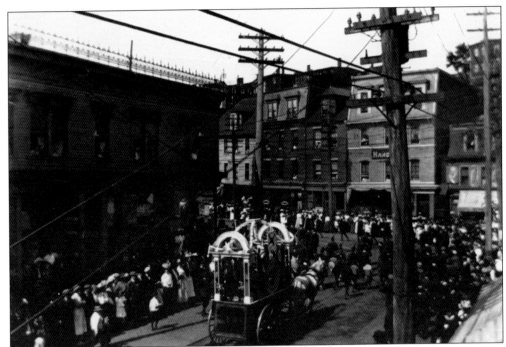

The location of this parade is where Mill Street used to connect with Paradise Row. Main Street would be to the left and Paradise Row to the right. The occasion and date are unknown, but the dress of the spectators (note the ladies in fine clothes to the left of the float) would indicate this is a late-19th-century occasion. (Courtesy Harold Wright.)

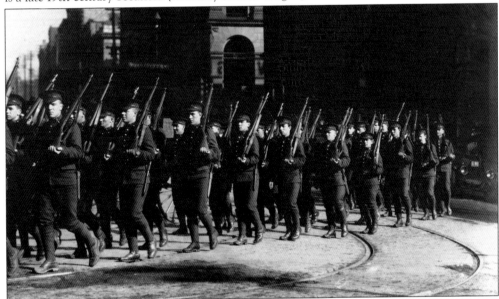

Military units often held parades in the city, as in this case with the parade moving down King Street to Market Square, where reviews were often held by the members of the royal family in town or by the lieutenant governor, the mayor, or military officials. Such parades held up traffic, such as streetcar No. 61, Haymarket Square; thus, they have become less popular over the years. (Courtesy Duffy collection.)

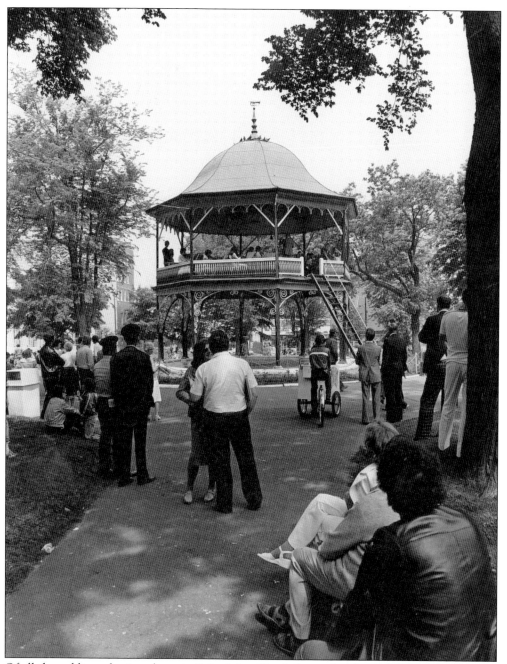

Of all the public gathering places in Saint John, King's Square has been the most popular over the years. Its focal point is the mid-square one-of-a-kind two-tiered bandstand, which was given to the citizens by the City Cornet Band in 1909 and officially named as the King Edward VII Bandstand in honour of the reigning monarch of the era. (Courtesy Rod Stears and City of Saint John.)

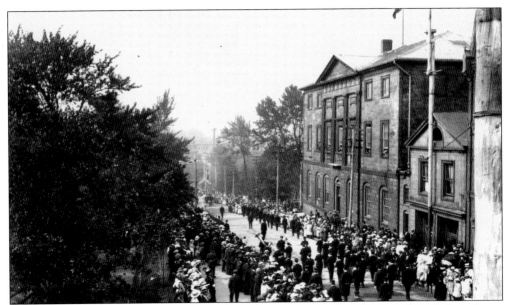

Here is another photograph of a parade when it is worth looking at the crowd on Sydney Street to observe their dress as a way of dating the photograph. According to information on the back of the photograph, amateur photographer A. V. F. Duffy dated it as 1930, and there is no reason to doubt his information. (Courtesy Duffy collection.)

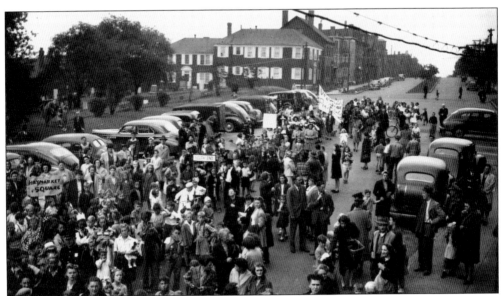

Many, if not most, of the parades in Saint John (save the Santa Claus parade, which began in 1951 and was the first such parade in the Maritimes) formed up on King Street East. A. V. F. Duffy identified this as a Masons' parade in 1946. Note how the dress has become more casual in the three comparative photographs where this was mentioned. (Courtesy Duffy collection.)

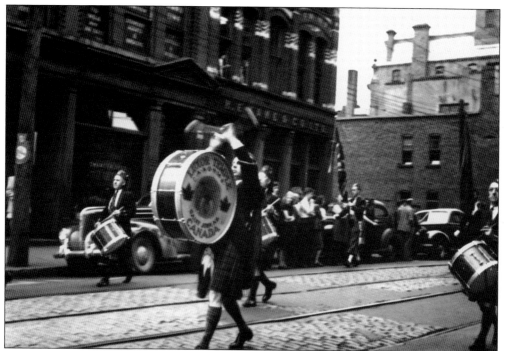

The Masons and Shriners could always be counted on to hold a colourful parade in conjunction with their business meetings each summer. Again, a photograph is found from A. V. F. Duffy to illustrate one of their efforts. He did not date this one but identified it as "Henry D. Hopkins on parade." The location is clearly Prince William Street, but the drummer does not appear to be Hopkins. (Courtesy Duffy collection.)

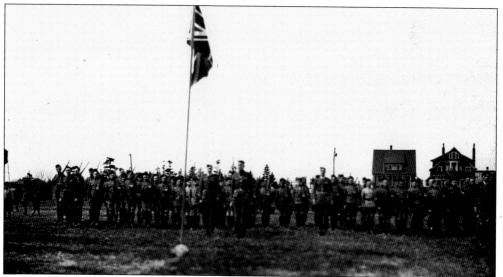

New Albert School was one of several that utilized Cadet Corps as part of the extra curricular activities when World War I broke out. With no suitable land near the school, they held their drills on Cochrane's field, about a kilometer away. It is now the site of Fundy Height's housing development, but in 1932, as can be seen, there were only a few houses in the area. (Courtesy Fred Miller.)

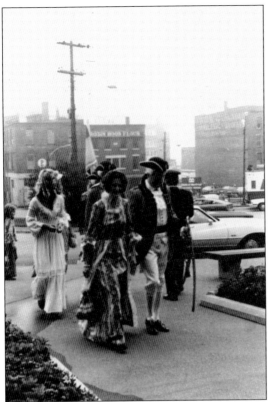

When Loyalist Days began as a community-wide celebration of Saint John heritage in 1971, the big feature of opening day was the landing of the Loyalist ceremonies at Market Slip. All the participants dressed in period costume and were rowed into the slip and then, as seen here, would march to city hall for a flag-raising ceremony and round of speeches, followed by some food and drink.

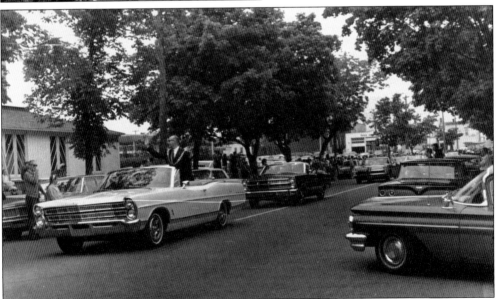

Canada's centennial year, 1967, was the cause for many public events and parades, not only downtown but throughout the city. This may have been the last public parade in the city of Lancaster, formed in 1953. On July 1, Saint John Mayor Joe MacDougall is seen waving to the crowd on Manawagonish Road. Six months later, Lancaster was forced by the provincial government to amalgamate with Saint John. (Courtesy Peter Prebble.)

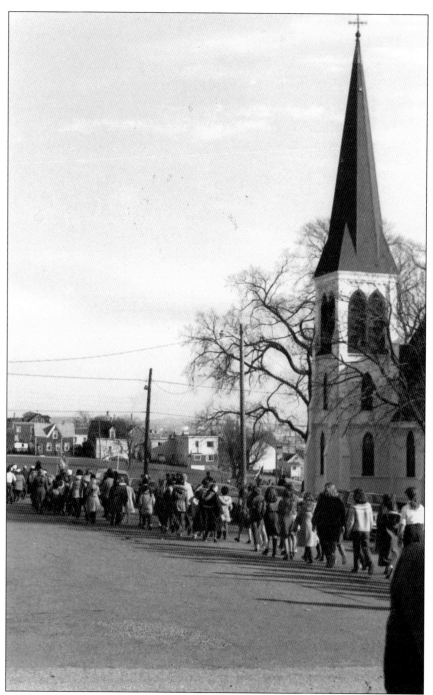

Area churches sponsored rallies that often involved a parade to show the strength of their youth movements, which usually included Scouting and Guiding. In this case, a parade is passing St. Jude's Church on the west side (where Scouting began), and the youths are marching past Queen Square a half dozen blocks to the Carleton Legion Cenotaph on Ludlow Street to participate in a Remembrance Day ceremony. Remembrance Day is still widely observed by young and old on parade in various areas of the city where there are memorials to the veterans.

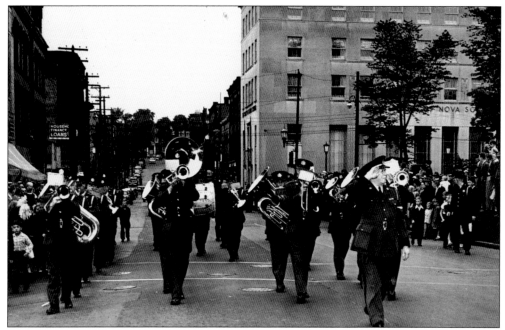

The days when Saint John had half a dozen citizens or marching bands has all but ended. One band is still active, that being the St. Mary's Band, founded in 1903 as an outreach of an Anglican Church, St. Mary's, then in the East End of the city on Waterloo Street. The band has survived two world wars, the dawn of the television age, and changing tastes in music that have resulted in several other bands, like the City Cornet Band, Fairville Citizens and Marching Band, and the Carleton Cornet Band, ceasing operations. The top photograph shows St. Mary's marching on Charlotte Street in a Christmas parade in the 1950s, and bottom is a concert in the King's Square bandstand, second level, in 1979, with Howard Neill as director. (Above, courtesy St. Mary's Band; below, courtesy City of Saint John.)

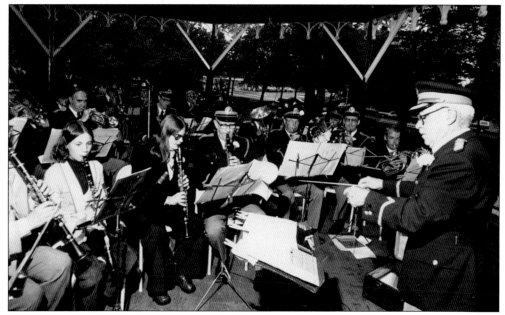

Eight

AT PLAY

In was in 1901 that Saint Johner Mabel Peters began a national campaign through the Council of Women for the establishment of public playgrounds for children across Canada. Ultimately, Saint John heeded her call and established a playground at Centennial School, which opened on July 3, 1906. This chapter shows some of the activities in the 80 years following Peters's initial idea, which led to the formation of a recreation service and the development of beaches, such a Dominion Park, shown here. (Courtesy Saint John Leisure Services.)

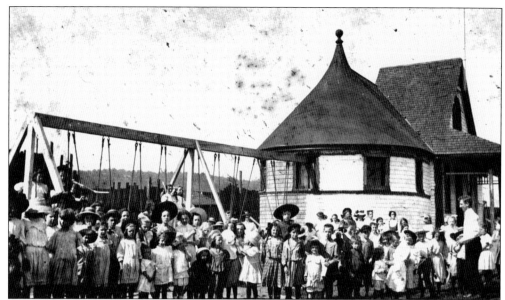

In 1913 the first annual report of the Playground Association included a number of photographs showing the work it was carrying out in the South End and East End of the city, namely the Allison and Aberdeen playgrounds. In the early 1990s a local collector bought the original photographs in the 1913 report, along with a copy of the report and some additional photographs of the era, including the two shown here. This added greatly to the understanding of play and playground conditions of the time. Note particularly the dress of the children, especially the girls in dresses and almost all with hats. Note the boys hanging on hoops that would be considered a safety hazard on a modern playground. (Courtesy Terry Keleher.)

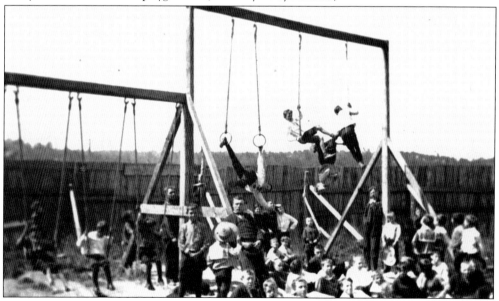

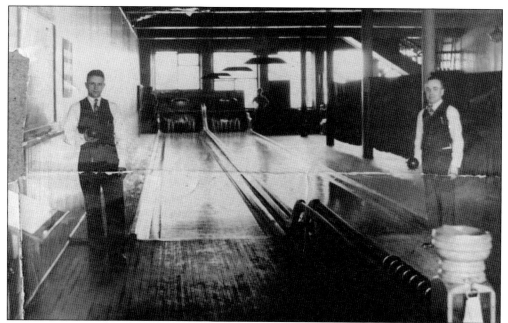

Before 1946, and the "official" recreation initiative, many sporting events occurred through private sponsorship. One example was when a bowling record was set in the city on February 9, 1933. Donald McCavour, left, and Walter R. Golding, right, completed 21 hours of non-stop action at the Central Bowling Alley, averaging 100 for the 200 strings. The feat made the front page of the *New York World Telegram* the next day.

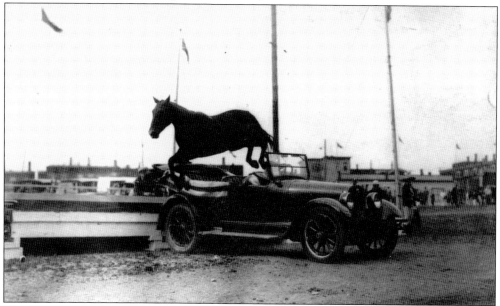

The Saint John Exhibition was the site of many athletic competitions over the years. Even as cars became more numerous, there were those who still believed automobiles would never replace horses and went to great lengths to prove their point. One such occasion is shown here, as this mare flies over a car. Who ever heard of a car being able to leap a horse! (Courtesy Harold Wright.)

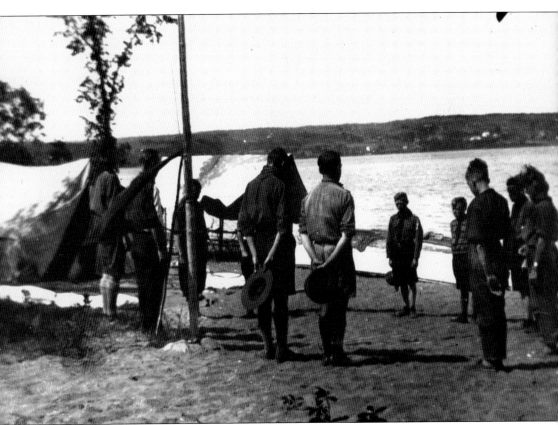

When Scouting arrived on the scene in New Brunswick in Saint John West's St. Jude's Church in September 1910, it quickly grew to become the leading youth activity of the province and held that position until the mid-1960s, when sport activity began to dominate the scene. From the beginning, Scouting's number one draw was the outdoors. When the "out" came out of Scouting, it began to lose ground. The photograph here is of a St. George's Summer Camp at Day's End in 1932 and was typical of such camps troops held annually for years in the first half of the 20th century. (Courtesy Fred McIntyre.)

Eugene Zed, chair of the Recreation Commission, examines the crafts created during a summer of supervised playground activity in the early 1950s. The location is the Shamrock Grounds, a war assets building converted to a field house in the North End of the city. In 1955, when Sears (see page 69) took over the running track, sports fields, and former K Grounds (considered the finest in Maritime Canada in the late 1930s), the field house was moved to the New Shamrock grounds, a few blocks away off Visart Street. The crafts shown would be displayed at the exhibition grounds, and some would be selected as winners in the various categories, which delighted the children, of course. (Courtesy Jeanne Taylor.)

The Recreation Commission of the 1950s became the Recreation Advisory Board in the late 1960s, when C. E. "Nick" Nicolle became director of the Recreation Department. It was a time of unparalleled growth, and Nick strongly believed in citizen involvement in the projects undertaken. From left to right are unknown, Ralph McLennaghan, Fred Tobias, Mike Murray, Nick Nicolle, Tom Higgins, and Joyce (Wilkes) Losier. (Courtesy Saint John Leisure Services.)

Mayor Bob Lockhart, center, accepts the key to the playgrounds of the city as they are opened for another season on July 7, 1971. Presenters are Joan Speight on the left and David Ferguson on the right on behalf of the children of the city. Athletic and energetic himself, Lockhart was a big supporter of recreation activity during his two terms as mayor, 1971–1974 and 1980–1983. (Courtesy Saint John Leisure Services.)

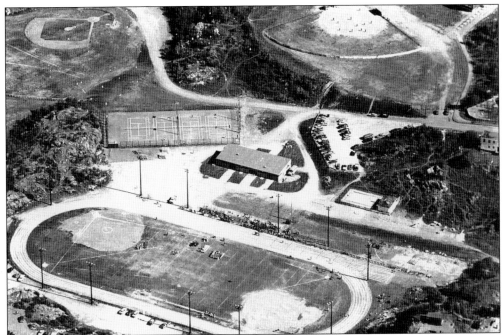

This aerial view is of New Shamrock Park, built after the former grounds became Sears and the Fairview Plaza in the mid-1950s. Formerly a limestone quarrying area and bisected by Newman's Brook, both disappeared in the development as the park became the city's number one sports field complex with its lighted softball and hardball fields, football grounds, tennis courts, track and field facilities, horseshoe pitches, and a modern change house. (Courtesy Saint John Leisure Services.)

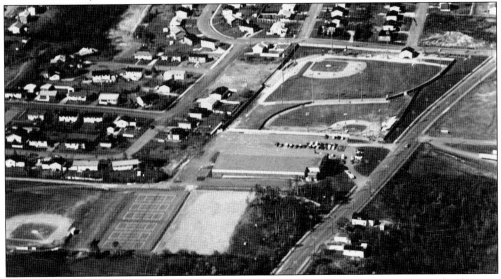

This aerial view looks west of Memorial Field in Saint John West. It was first proposed to honour veterans following World War II. It developed in piecemeal fashion, primarily following selection of the site for the erection of the Lancaster Centennial Arena in 1966. It still operates as the Peter Murray Arena. Other facilities include tennis and lighted fields for softball and senior-level hardball. (Courtesy Saint John Leisure Services.)

In the late 1970s a committee of citizens and the Recreation Department began the process of bidding for the Canada Games to mark the city and province's 200th birthday in 1985. The successful bid resulted in what was arguably the city's zenith in recreational activity of the 20th century. It was judged a huge success, but, sadly, economic times that followed resulted in cutbacks to recreation services, and facilities developed for the athletes' use were not kept up. And although it too suffered budget restrictions, the Canada Games Aquatic Centre, shown in the background behind the mascot for the Canada Games, Fiddle Ed, managed to adjust and adapt and is today is the city's main legacy of the 1985 games. (Courtesy Patti Livingston and Saint John Leisure Services.)

Seven

THIS AND THAT

Miss Canada "

The discoveries made in over 30 years of offering Walk n' Talk programs in Saint John, and in writing some 3000 stories, have resulted in many photographs, ephemera, and collectibles that would not fit into any of the previous chapters. This chapter begins with one, a photograph of Winnifred Blair in 1922 when she was selected as the first-ever Miss Canada, and follows with glimpses of life in Saint John that are important links to the understanding of the city that this book has profiled.

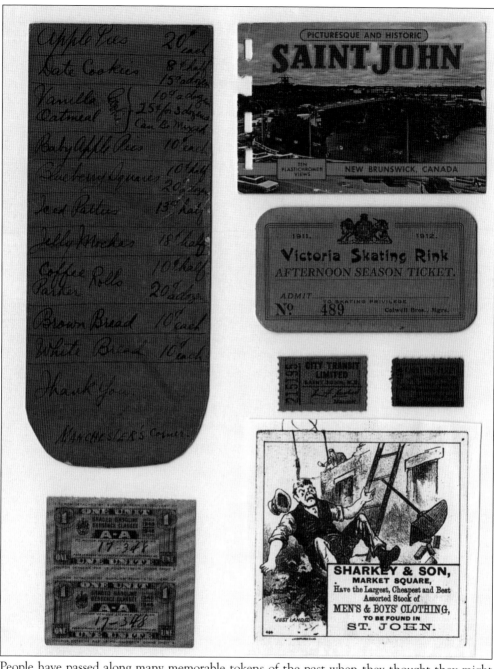

People have passed along many memorable tokens of the past when they thought they might be of interest or result in a story to be shared more widely. Here are, clockwise from the bottom left, a gas ration ticket from World War II; a 1930s baked-goods list that Pauline Magee used on Manawagonish Road when assisting her dad selling the bakery items he cooked there; a 1950s early use of colour cluster postcards produced by the Saint John News Company; a 1911–1912 patrons skating pass for the Victoria Rink (see page 61); a bus ticket and ferry ticket, before 1953; and an early advertisement for a Saint John merchant Sharkey & Son, which shows imagination and humour.

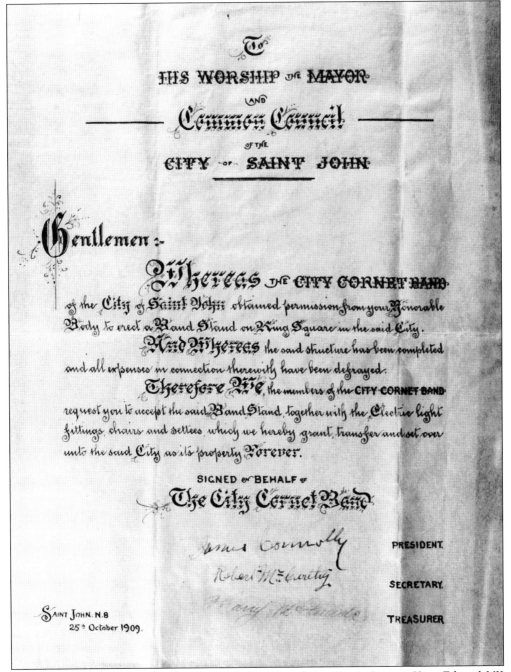

To

HIS WORSHIP the MAYOR

and

Common Council

of the

CITY of SAINT JOHN

Gentlemen:—

Whereas the CITY CORNET BAND of the City of Saint John obtained permission from your Honorable Body to erect a Band Stand on King Square in the said City.

And Whereas the said structure has been completed and all expenses in connection therewith have been defrayed.

Therefore We, the members of the CITY CORNET BAND request you to accept the said Band Stand, together with the Electric light fittings, chairs and settees, which we hereby grant, transfer and set over unto the said City as its property Forever.

SIGNED on BEHALF of

The City Cornet Band

James Connolly — PRESIDENT.

Robert McCarthy — SECRETARY.

Mary McArdle — TREASURER

Saint John. N.B
25th October 1909.

The official document of October 25, 1909, transferred the King's Square, King Edward VII Bandstand from the City Cornet Band, which paid for its construction, to the City of Saint John, which has maintained it since. See also page 103 for another look at the bandstand referred to. (Courtesy Saint John Leisure Services.)

A blotter, a necessary item in the days of fountain pens, was a popular way to advertise when motorcars were just beginning to become commonplace in the 1920s and 1930s. The owners of the Leinster Street Garage show a bit of humour on this blotter. The car may look quite far gone, but early cars could be and were repaired much more readily than is the case today. (Courtesy Art Pottle.)

ONE OF THE WORLD'S BEST LOVED PICTURES

© Art Education, Inc., N.Y. Printed in U.S.A.

AVENUE OF TREES **DUTCH**
Meindert Hobbema (1638–1709) National Gallery, London

M. H. McCAVOUR

Near Reversing Falls Bridge

ALL KINDS OF FISH IN SEASON

Phone 3-2248
Residence 3-1925 ST. JOHN, N.B.

M. H. McCavour was as famous for his "fish" signature, as he was for the Saint John Harbour Salmon he shipped overnight to Boston and New York markets. When he paid a bill he was not happy to be writing a check for, such as his taxes, the salmon signature would be frowning, not smiling. (Right, courtesy Dorothy Stears.)

This Italian pink granite stone to Eliza Mae McIntosh was destined to honour a deceased person in Ontario. It came to Saint John by ship, but there were further charges to move it 500 miles west, and the Ontario folks refused to pay. Thus, it was sold at auction to the McIntosh boys, local cartmen who could easily move it to Cedar Hill cemetery in honour of their mom.

James Briggs Jr.'s stone stands in the Thorne Avenue Church of England Cemetery. Sadly, few stop to read it today. It clearly tells the tragic story of his murder, or as it says, "assignation," as he was passing Long Wharf on the night of September 6, 1847. He was an innocent victim of clashes between Protestant and Catholic, or English and Irish, raging in the city at the time.

Lord Baden Powell of Gilwell, chief scout of the world, visited Saint John four times between September 1910 (when he snuck into the city unannounced) and 1935. He poses here on his last visit to the city with Lt.-Gov. Murray McLaren at Government House, Coburg Street at Garden Street, Saint John. More than 3000 boys (and many girls too) gathered at the Barrack Green Exhibition Grounds in South End Saint John to greet their chief the day after this official photograph was taken on May 31, 1935. (Courtesy Boy Scouts of Canada, New Brunswick Council.)

Promotions of New Brunswick as a tourist destination, as pictured here, date back to the 1880s. Saint John was first to produce brochures because steamship links with Boston could be done overnight and thus made visits to the city easy. Rail service to the province was also good in that era. Then, as now, Reversing Falls was a phenomenon everyone wanted to experience.

One feature that captured the attention of American visitors was (and is) the Royal Hanoverian Coat of Arms that hangs in Trinity Church. Its original home was the Massachusetts State House in Boston, but, as such symbols of British Imperialism were being cut up and burned, Loyalist Edward Winslow removed it from Boston and had it moved to Saint John where it would be safe from destruction. (See also page 31.)

MRA (see page 35) took advantage of every opportunity to hold a sale. In this case, twigging on the Loyalist City's roots to England, an Empire Day sale is held. The store had upward of 400 employees, and it seems almost all of them signed the border of this promotion. Empire Day is no longer observed in Saint John, although Victoria Day is still marked on the third Monday in May. Few, however, celebrate it as the queen's birthday, which is how it all began.

The riverboat era began with the service on the Saint John River of the steamship *General Smythe* in 1816 and concluded in 1946 when the motor vessel *D. J. Purdy*, shown here, was removed from service. Just one year before that era ended, Dr. William MacIntosh (front, left), director of the New Brunswick Museum and canoe enthusiast, is shown with a group that has just finished a multiday canoe trip on the Saint John River and on July 28, 1945, is returning to Saint John on the *D. J. Purdy*. (Courtesy Edith Andrews.)

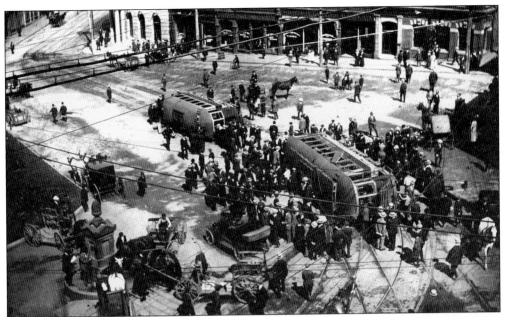

Streetcar service began in Saint John with cars that ran from Indiantown in the North End to King's Square in the city centre on October 17, 1887. One of the more memorable incidents in the 61 years that the service lasted (1948 was the end) is pictured in the upper photograph. It was a streetcar riot that occurred on July 23, 1914, and it resulted in the overturning of two streetcars at Market Square and the breaking of many windows in nearby buildings. The last of the rotting remains of the Saint John streetcars, many of which were built in the city, is shown in the lower photograph, which was taken by Dyson Thomas at Five Fathom Hole in 1993. (Above, courtesy Norm Wasson; below, courtesy Dyson Thomas.)

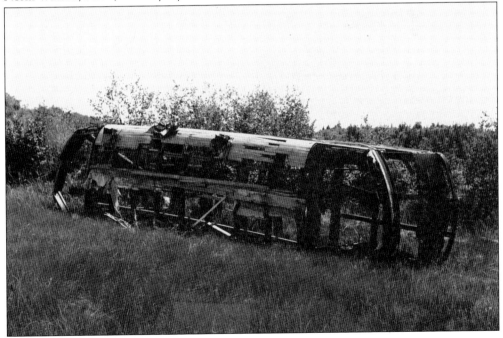

The gents pictured in the top photograph probably thought the era of the horse had come to an end in the 1930s photograph. Employees of the dry dock, they were out for a spin in their Chevrolet on Bayside Drive. Stella Maris Church is pictured in the background. Built in 1924, it had a base for a tower, which was never completed, but shows in this photograph. The lower photograph proves horses continued to work in Saint John. This is the early 1970s, and the Rockwood Park team is getting some exercise between sleigh rides and tallyho rides by helping in the annual spring cleanup. (Below, courtesy Jackie Clark.)